S0-AFR-998

BARRON'S ART HANDBOOKS

FIGURES

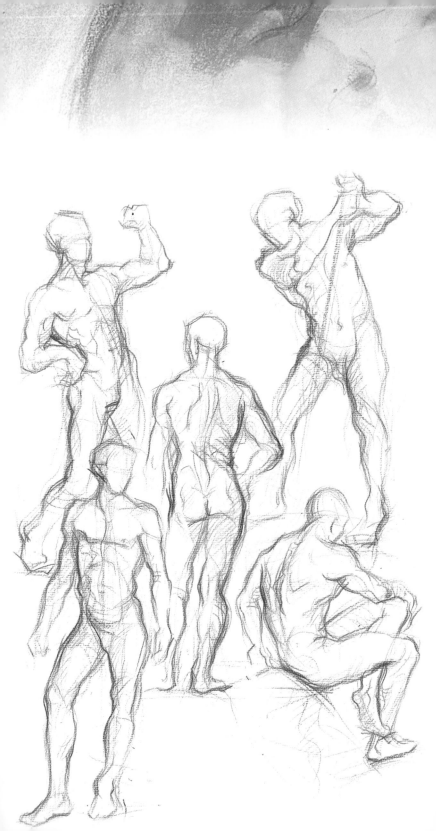

BARRON'S ART HANDBOOKS

FIGURES

BARRON'S

CONTENTS

THE EARLIEST APPEARANCE OF FIGURES IN ART

The earliest figures to appear in art were of an entirely religious and magical nature. They were not intended to be realistic, but to capture the essence of the human being through symbols and shapes. During the Paleolithic period, figures came to be represented in a relatively naturalistic manner. The creativity of these anonymous artists was innocent in nature, although they had a capacity for synthesis and likeness that has yet to be rivaled.

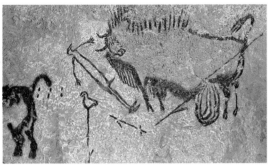

Bison and Prone Man. *Lascaux. Early representations of man were associated with magic and ritual. This example may show a hunting scene.*

The Figure as a Symbol

The earliest representations of the human figure were intended to satisfy the spiritual needs of Paleolithic man in two basic areas of his existence: hunting and concepts of the hereafter. For this reason, Paleolithic cave paintings always depict either hunting scenes or rites associated with the dead.

The first artistic expressions were created, therefore, to satisfy early man's spiritual needs. Today the figure in art is not merely a representation of mankind but also contains a high degree of self-recognition, on the part of both the artist and the observer. Proof of this is the respect we show to the images of people we love or admire, to the extent that tearing up a photograph or portrait of a loved one is tantamount to breaking off relations.

The earliest anthropomorphic representations were semi-human figures, with sufficient features to render them recognizable. Cave painting.

Line and Mass

These initial representations of figures were purely linear and schematic, synthesizing forms almost to the same degree as minimalist art. As they progressed, the depiction of the body gained in volume, although in these early renderings the masses of color that composed figures were uniform and did not distinguish between the shadings and textures of the different parts of the body. On the other hand, the animals at that time were painted with a wealth of detail, both in form and in volume and color.

Figures and Symbolism

Throughout history, the figure has appeared in different cultures as mankind's attempt to approach the gods. Divinities have typically been depicted in anthropomorphic fashion. One only needs to survey briefly the major cultures of the world to see the constant presence of pictorial represen-

Lovers Strolling Through a Garden. *Wall painting of the New Kingdom, Egypt. Egyptian murals are of a highly symbolic nature and almost always refer to life after death.*

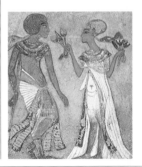

Figures in Ancient Cultures

The figures from the art of ancient cultures are not rough or primitive due to the artist's ignorance. Rather, they are a result of the aesthetic criteria of the society that produced them, in the same way that toward the end of the 20th century the figure is represented in many ways without any loss of creativity by the artist. The figure is represented in different cultures with the same credibility, for the artist as well as for the spectator. Thus, we cannot say that a contemporary artist is any more capable of representing the human figure than his anonymous equivalent during the Paleolithic period.

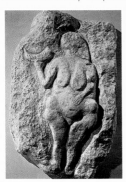

Venus with a Horn.
The expressionism of primitive art has been a source of inspiration for many contemporary artists.

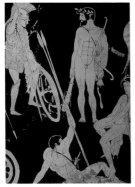

Heracles Surrounded by Heroes.
A detail of an Attic krater (456 B.C.) Mythology was the predominant theme in Greek art.

tations of the gods. Egyptian, Greek, pre-Columbian, Indian, or Judeo-Christian cultures have maintained a continuous line of religious symbolism through the representation of the human figure.

Each age in history has had its own characteristic way of representing figures, irrespective of the pictorial medium used.

The Human Figure in Egypt

The country that remained unchanged, both socially and culturally, for the longest period of time was Egypt. Their representations of man and his relationship with the divine were almost always *post-mortem.* That is, Egyptian art is fundamentally funerary and seeks to capture faithfully the actions and possessions of the departed in their earthly life so they may be available to them in the afterlife. Figures are almost always represented from a double viewpoint: The body is frontal while the head and legs

are in profile. The pose is hieratic and motionless, although certain representations contain lines that are more sinuous and seek to depict the movements of the body.

From Figures to Writing

The narration of a series of scenes through images was undoubtedly the birth of writing. This system of narration survived in major cultures such as the Egyptian for thousands of years. This system of hieroglyphics was also developed by other cultures until these symbols came to constitute the signs of a true written language. Such a transition was, of course, far from spontaneous and required a constant evolution in the perception of the figure as a symbolic and, later, artistic element, together with man as the narrator of his own history.

MORE INFORMATION

• The figure in painting **p. 8**
• Obtaining the proportions of the figure **p. 14**

The Tribe of the Semites Requests Permission to Enter Egypt. *Tomb of Beni-Hasan, Thebes. Mural from the Middle Empire. Partially lateral and hieratic treatment and symbolism were the bases of Egyptian wall paintings. The frontal-lateral representation of the figure serves a didactic function and is intended to provide as much information as possible to the human or divine spectator.*

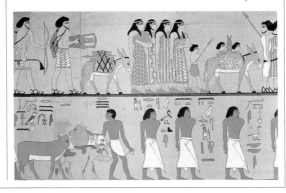

THE FIGURE IN PAINTING

Since the beginning of art, man has represented himself in as many ways as his imagination and technical skills have allowed. Throughout both prehistoric and recorded times, the iconography most commonly used by artists has emphasized the human being. Placed in a given context or in isolation, the clothed or nude figure has been the main center of attention. It is important for the artist to bear in mind the way in which the representation of the figure has evolved over different periods and within different pictorial contexts.

The First Iconographic Representations

The first examples of figurative representation date back to cave paintings, in which everything represented is of a magical or symbolic nature. These early artistic expressions are a legacy both in skill and synthesis of form.

Unlike an easel painting, these figures were represented without a defined context, occupying a limitless space, and were primarily depicted in dancing and hunting scenes (always associated with religious or magical themes).

Cave painting representing human figures. Cave of Chimanimani, Zimbabwe (detail).

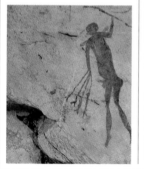

These primitive figures were by no means rough or crude, but revealed great spontaneity and movement, both in form (iconography) and in the characters depicted (iconology).

Venus de Menton. Museum of Saint-Germain-en-Laye. The expressive skill of primitive peoples is still valid in contemporary art.

Wall painting of Campana Terracotta (530 B.C.). In these representations, the figures still appear in profile.

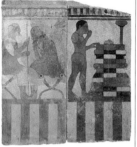

The Figure in Greece

Greek culture had without a doubt the greatest influence over the Western world. From the Archaic to the Hellenistic periods, Greek art evolved from an ideal based on the human model to one in which the artist sought perfection through beauty. The Greeks' achievements in the representation of the human body were such that they became a canon still in use today.

Woman Being Flogged and Dance of the Bacchante. Villa of the Mysteries, Pompeii. Few Roman paintings still exist; however, because it was buried in the ashes of Vesuvius, Pompeii is one of the rare sites where we can see mural paintings preserved.

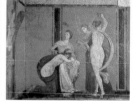

The Medieval Innovation

The representation of the human figure emulated Greek art throughout the Roman Empire. The decline of Rome gave way to a period of obscurantism in art and culture in general. The Greek canon and classical forms disappeared with the advent of the Romanesque style. The ideal of beauty in representing the human figure was replaced by a didactic artistic endeavor in which the figure's only purpose was to depict sacred or war scenes. The Greek models were forgotten to such an extent that figures lost their foreshortening and were represented as frontal, hieratic planes.

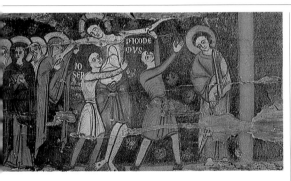

Scene of the Passion *(c. 1200). Altar piece. The figure ceased to be realistic and moved to a more symbolic plane.*

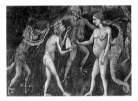

Giotto, Judgment Day *(detail; c. 1305). Scrovegni Chapel, Padua.*

Modern-day Figures and Their Primitive Models

From the Renaissance to today, the figure in painting has hardly evolved in the classical sense. Yet since the end of the 19th century, the emergence of the Impressionists and all the avant-garde movements that followed radically changed the concept of the figure through the use of pure color, since they could not compete with the recent photographic depiction of the figure. These movements treated the figure in many ways, from an iconographic as well as a stylized point of view, which, in Cubism and Expressionism, referred to the primitive representation of the human figure.

Ramón de Jesús, The Symbols of Power *(1994). Symbolic references in 20th-century painting constantly refer back to the primitivism of cave paintings.*

The Sources of Cubism

Both Braque and Picasso revolutionized the concept of painting. Their Cubist artistic creations not only assimilated the formal synthesis achieved by Cézanne, but were also inspired by different African cultures, from the expressionism in their forms to the study of their different visual planes.

Roger de La Fresnaye, The Bathers. *Cubism, particularly in its treatment of the human figure, shows clear references to African art.*

The Renaissance and Classicism

After the year 1000, Western society entered a period of economic prosperity that led to the emergence of a new class, the bourgeoisie, which had the means to build large cathedrals. This economic upturn also had an impact on the world of culture and art, with a return to the study of the nature of man. The Gothic period in Italy gave way to the Renaissance, which, as its name indicates, saw a revival of Greek and Roman culture. The canon of the figure was not only reintroduced, but evolved even further. New techniques, such as painting with oil, coupled with the rebirth of figurative representation, were responsible for a period of virtuosity unrivaled in the history of art.

Andrea Mantegna, Saint Sebastian *(1480). Mantegna was one of the first artists to reintroduce foreshortening and perfect modeling in his Renaissance figures.*

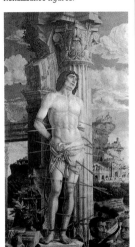

MORE INFORMATION

• The earliest appearance of figures in art, **p. 6**

• Compositions with the figure, **p. 20**

POSES: *CONTRAPPOSTO*

The human figure can be represented in many different ways. A drawing based on the figure's anatomical structure and the relationship between the hips and shoulders and the other limbs is called *contrapposto*—the "play" between the balance of the lines that make up the axes of the body. The ischiatic position is a way of representing and viewing the human body in a more relaxed and natural manner.

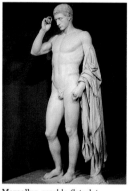

Marcellus, *marble (late 1st century). The ischiatic system rests on the ischiatic pose; when the body rests on one leg, the hip angle changes slightly. This is the most common pose throughout the history of art.*

Different sketches of the ischiatic pose.

The Main Structure of the Body

Just as the skeleton supports the muscles and provides the main structure of the body, drawing provides the structure for all types of pictorial representation. Thus we can establish a certain parallel between what drawing is to art and what the skeleton is to the human body.

In order to represent the ischiatic position correctly, you must first be aware of how the relaxing of the limbs produces a balanced effect in a pose. It is this shifting of the hip position that lends balance to the construction of the drawing.

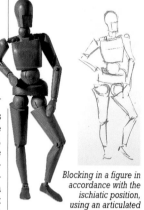

Blocking in a figure in accordance with the ischiatic position, using an articulated mannequin.

The Trunk and Its Axes

The structure of the human body is divided into three basic axes, which cover all the movements and the shifting weight of the body. These axes can be compared to two sets of scales that distribute the differ-

ent weights. They correspond to the line of the shoulders and that of the hips, with both lines balancing on the spinal column, which makes the third axis. The weight of the different limbs and other parts of the body shift in accordance with the angle or bend of the axes.

The Weights of the Body

A change in any of these axes in a pose produces a shift in the weights of the body, so that when one axis slants to one side, the other seeks to offset the weight.

Contrapposto also helps to increase the natural aspect of the human figure represented in more complex poses.

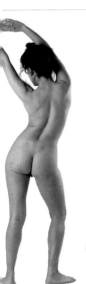

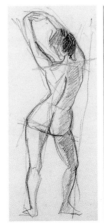

tudy of the distribution of the different weights of the body produced by a shift in the axes.

Understanding how one variation in the structural axes of the body gives rise to another in relation to the spinal column allows for a more anatomically correct depiction of the body.

A slanted hip allows the opposite leg to rest more freely, but it also means that the leg now supporting all the weight is necessarily stiffer.

Practicing *Contrapposto*

The best way of familiarizing yourself with the use of *contrapposto* is by painting and drawing on a daily basis, working both from nature and by imagining sketching exercises in which the axes of the body alternate, shifting the weight between the shoulders and the hips in relation to the line formed by the spinal column.

Blocking In and the Ischiatic Position

It is the blocking in of the figure that really supports the weight of the different limbs, so the axis lines of the hip and

shoulders should be carefully studied and outlined to guide the construction of the rest of the figure.

When blocking in a figure, the lines representing the hip, shoulders, and spinal column should be perfectly defined.

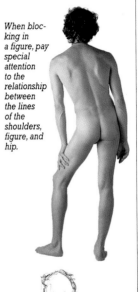

When blocking in a figure, pay special attention to the relationship between the lines of the shoulders, figure, and hip.

An Almost Sculapturelike Construction

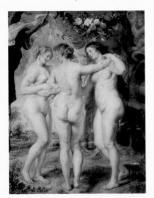

Using the ischiatic position in drawing always produces natural results, with the figure represented almost as if it were a sculpture. The weights are balanced with the volume, making for an elegant, balanced pose.

Peter Paul Rubens, The Three Graces. *A perfect anatomical study in which the ischiatic position provides the basis for the pose.*

MORE INFORMATION
• Obtaining the proportions of the figure, p. 14
• The figure as a method of study, p. 28

PROPORTION AND PLACEMENT OF THE FIGURE IN PERSPECTIVE

The relationship between the model and the rest of the objects and figures appearing in the picture is based on the relationship of proportions that arise from the plane the figure occupies and from the perspective. Not only must the proportions of the model be observed, but the same measurements must be applied to the surrounding objects in order to create a logical context for both the artist and the viewer.

Proportions and Size

When observing a figure, always take into account the context in which it appears, noting the distance separating it from surrounding objects. One way of understanding the figure and the objects around it is to establish a system of measurements using a known factor. When working on a figure, take this factor from the figure itself—the size of the head or the width of the figure, for example. This model can then be used to calculate the proportions of the surrounding objects.

MORE INFORMATION

• The figure and color ranges, **p. 24**

Importance of Depth in Figures

When attempting to define the correct proportions between the figure and the surrounding objects or people, remember that concise blocking in is one of the main aids to achieving the correct relationship between the different proportions of the drawing. The main theme should be the center of attention, without the surroundings detracting from it in any way. So any forms or objects that are not essential to the picture should be eliminated. Any lines that may unnecessarily complicate or cloud a simple image should be removed. With a basic sketch of the main lines, it is easier to calculate the different proportions of the objects and the figures.

Constant Reference Points in Perspective

To achieve the correct proportions of the figure and its surroundings, it is necessary to make constant use of reference points, paying special attention to the various distances between the figure or figures and the edges of the picture, as well as any other secondary figures or objects present.

In order to find logical reference points in the picture, first locate point (B) where a figure is to be placed. From the unit of measurement, in this case the main figure, lines of perspective are drawn from the base and the top, passing through (B). On the horizon line (HL) the vanishing point (VP) is placed where the vanishing lines converge. Using the different proportions of the main figure (E, F, G), these lines of perspective can be transferred to the new figure. The height of the figure (H) is achieved by extending parallel lines (I, J). Repeating this method with different vanishing points can create new figures, as seen on the following page.

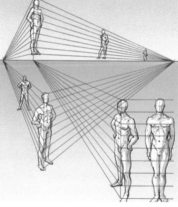

There exists a given relationship in proportion and perspective between the different figures or objects in a drawing. The guideline for reducing these forms has been obtained by extending the lines of perspective, using the measurement of the figures in the foreground.

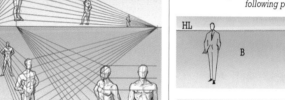

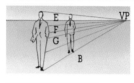

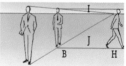

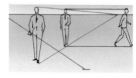

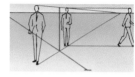

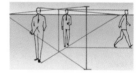

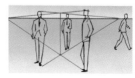

Distorted Proportions in Surrealism

Surrealism is an artistic movement claiming to give a modified or altered view of reality as we see it in our dreams. Figures in Surrealist art often appear distorted and formless, as if they were made of chewing gum. Even the proportions of the figure with respect to the other objects in the painting are altered, as are the planes, which sometimes occupy illogical positions.

On other occasions, Surrealism uses the relationship between the different objects of the picture to form figures that exist only in the mind of the beholder—quite a metaphysical experience.

Salvador Dali,
The Battle of Tétouan

A. Depending on the variation in the incline of the ground plane, the figures' positions should vary with respect to each other.
B. The high horizon line and its use in perspective situates the figures.
C. Example of a seated figure according to correct perspective.

A

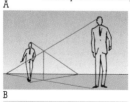

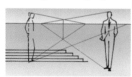

B

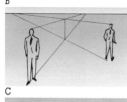

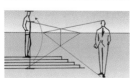

C

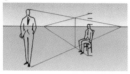

Perception and the Picture Plane

The way we view the model can vary a great deal with the slightest movement, so it is all too easy to lose a sense of the proportions if there are no set points from which to establish the distance of the model. If we have moved from our starting point, we can always find the original proportions by using the reference modules established at the beginning, thus preventing any variation in the proportions of the model with respect to the picture. For example, if the figure is seated, the distance with respect to a nearby object can be measured by holding a pencil or brush with the arm outstretched. If the viewpoint is lost, all we need do is resituate the measurement to find the original position.

Planes Within the Picture

Proportions can be established using the different planes of the picture. These planes establish the distance of the artist from the different objects or the figure of the model.

These planes can be used to divide the picture into horizontal sections, thus simplifying the task of finding the different proportions between the figure and the surrounding objects.

OBTAINING THE PROPORTIONS OF THE FIGURE

Proportion is based on arithmetic, that is, if a unit of measurement is established as the basis for determining the proportions of a drawing, this same unit will be the constant reference point for the plane of that picture. For example, if the unit of measurement for a figure is taken as the tip of the artist's thumb, which corresponds to the size of the model's head, this same system should be used for all the remaining measurements of the body: one unit for the head and one and a half for the shoulders.

Anatomy and Proportion

In a figure, each part of the body is closely related to the other. If the head is drawn correctly but the body supporting it is out of proportion, the artist has failed.

The study of anatomy is essential for representing figures both nude and clothed. The different proportions become easier to grasp once you understand the measurements of each part of the anatomy in relation to the rest of the body. You only need to refer back to the standard used for creating the human figure to understand the different measurements and proportions.

Measurements

The measurements of a figure can be established using a pattern, or standard. It is true that this standard is not realized in everyone; it is, in fact, an ideal that rarely occurs in nature. However, it can still serve as a guide, even when the figures do not exactly match this ideal. When calculating the measurements of the figure, it is not always necessary to resort to the seven and a half heads of the Greek standard, though it can provide a useful comparative tool. A figure may have long or short legs, or may be fat or extremely thin. Neither of these features will, of course, fit the established standard, yet a knowledge of this standard is of great assistance for studying the measurements of different individuals.

A

B

C

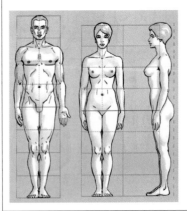

The figure corresponds to a standard which varies in accordance with the aesthetic considerations of the artist and of the age in which he lives.

The accepted standards for the human figure have varied constantly throughout different periods and styles: A. The Three Graces, by Hans Baldung. The standard of beauty corresponds to a thin body, budding breasts, and a swollen stomach. B. Venus and Cupid, by Titian. A standard characterized by an extremely sturdy body and small head compared to the previous Gothic standard. C. Nudes, by Badia Camps. The standard for present-day figures is far more flexible.

Proportion and Placement of the Figure in Perspective **15**
Obtaining the Proportions of the Figure
The Parts of the Body and the Sketch

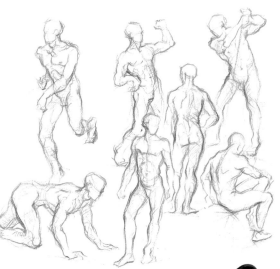

The pose may vary, but the proportions between the different limbs should always remain the same, taking into account the "hidden" lines.

Pose and Proportion

The model's pose should be compared with what we already know of anatomical proportions. A pose can often have complex lines interfering with our understanding of the proportions of the body, though these lines may not be immediately apparent in the pose. A twisted back or bent torso produces volumes that cannot be seen and their position depends on the axis of the spinal column and its position with respect to the other limbs.

A Unit of Measurement for the Model

In order to correctly transfer the proportions of the figure, it is of great help to have a system of measurement that can be marked on the drawing instrument itself. The brush or pencil can be marked by the artist to help him calculate the measurements of the model, by

holding up the instrument between himself and the figure. By repeating this action, all the distances between the lines that make up the structure of the model can be calculated.

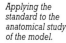
Applying the standard to the anatomical study of the model.

The Photographic Aid

A most efficient system for studying the different proportions of the figure is to start from a photograph of the model. This flat image enables the artist to reproduce the measurements faithfully, particularly when the pose is rather difficult to capture. This does not mean, however, that the artist must always rely on photographs; they should be used as an aid, not as a substitute.

Different Tools

Tools with a flat and straight edge can be used to calculate the measurements of a figure. A ruler is perfect, as the measurements marked on it allow you to transfer the distances and proportions from the model to the drawing. You need not be so precise, however, and simple things such as a small piece of cardboard, a folded piece of paper, or a pencil can all be used as measuring instruments.

MORE INFORMATION

- The parts of the body and the sketch, **p. 16**
- The figure as a method of study, **p. 28**

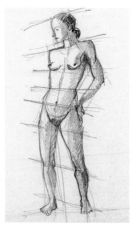

THE PARTS OF THE BODY AND THE SKETCH

Each part of the body is connected to at least one other point and implies a series of potential movements, while eliminating others that are not anatomically feasible. These variations can be represented using simple sketches, constructed with just a few lines that give a general overview of the different parts of the human anatomy.

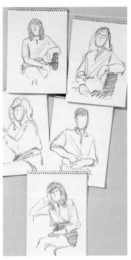

The sketch of the figure uses geometric shapes.

A Question of Geometry

Capturing the essence of the model and adapting it to the drawing requires first that it be reduced from three dimensions to two—that is, the process by which the artist observes the model and then transfers those planes to the drawing in two-dimensional form. This process of reducing the figure of the model to a flat plane is, above all, a synthesis. It is absolutely necessary for producing a correct representation of the figure on paper. It should be as concise as possible, and this reduction of the elements of the figure is carried out by blocking in the different parts of the body using geometric figures.

The Relationship Between the Trunk and the Arms

First, the trunk should be blocked in using a rectangular shape, which will eventually develop into a cylinder. The size of the trunk will depend first on the build of the person represented and second, on the proportions of the other limbs, going from the line of the shoulders down to the hips.

Other internal structures, made up of triangles, may then be added to the cylindrical shape. In translating the image to a three-dimensional plan, these triangles become conical forms and are meant to define the lines of the shoulders and hips.

MORE INFORMATION
- Obtaining the proportions of the figure, **p. 14**
- Live and artificial models, **p. 18**

The arms start from the shoulders with two round joints which help to represent movement. They are tubular in shape and

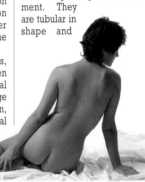

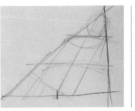

divided into two sections: The upper arm stretches from the shoulders down to the middle of the trunk and the forearm is of the same length.

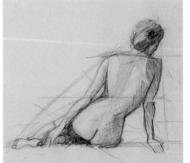

In this study, notice how the sketch has developed into a drawing. Starting from purely geometric shapes, the internal structures have been developed to complete the proportions between the trunk and the arms.

Obtaining the Proportions of the Figure
The Parts of the Body and the Sketch
Live and Artificial Models

17

The Legs: Support for the Pelvis and Hip

The pelvic area starts below the hip line and can be sketched as an inverted pyramid. The correct position of the legs corresponds to circles drawn on its surface. The thigh has the longest bone in the body and this fact should be carefully taken into account in comparison with the other limbs.

The legs support the trunk at the hip line. The upper and lower limbs of the body should be balanced to capture the mobility of the pose.

The Figure Standard and the Sketch

Throughout the history of art, the figure has changed continuously according to the dominant aesthetic standards of each period. The

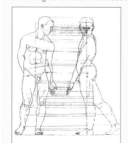

method of sketching the figure for each standard has remained the same, but the measurements have changed. The sketch helps to situate the volumes that represent the proportions.

Sketch for male proportions according to Albrecht Dürer.

The Spinal Column as an Axis

The central axis of the body is the spinal column. It is flexible and responsible for distributing different weights from the lines of the shoulder down to

the hip line. It allows the body to bend in different directions and the trunk to twist at the hip.

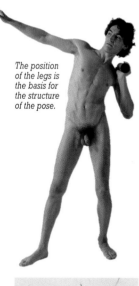

The position of the legs is the basis for the structure of the pose.

The spinal column is not rigid and allows for flexible poses.

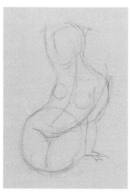

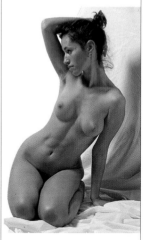

A Pattern for Different Measurements

Each part of the body has a set of measurements that remain constant independent of the pose. These measurements can be made into a scale, as if working with a pattern. If a separate scale is not used for each person, it becomes a standard scale or canon. This scale can easily be established by using the size of the head as a reference for each figure.

THE MEDIUM

LIVE AND ARTIFICIAL MODELS

A drawing or painting of a figure can be made from a live or artificial model or even from a photograph. A live model enables the artist to study a series of movements and variations in the pose, while an articulated mannequin is better suited to an in-depth exploration of the pose and the proportions. If both types of model are used, a complete anatomical study can be made and its results applied to various poses.

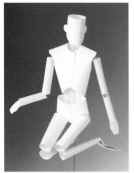

A female figure represented by an articulated mannequin.

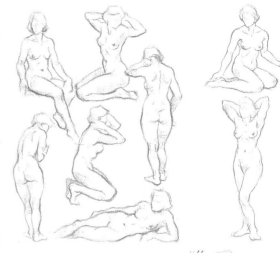

Comparing Poses

The model is the main reference for representing a figure and, consequently, must be carefully studied. A live model provides the artist with a wide choice of planes to choose from when drawing the figure. The selected plane can then be compared with the others in

Beginning with a real model provides a lot more information than using an articulated mannequin.

order to correct the construction of the figure or to reinforce it. In general, a photograph provides only a partial view of the subject. If the figure blends into the various planes of light and shadow in the photograph, interesting effects that would otherwise be perceived in the live model can be lost.

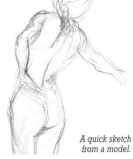

A quick sketch from a model.

The Parts of the Body and the Sketch
Live and Artificial Models
Compositions with the Figure: Still Life

19

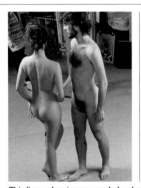

This figure drawing was made by sketching rapidly from models posing in the studio.

The Historical Use of Grids

Copying by grid has often been looked down on as a drawing technique, though this fact is relatively unimportant for our study. Many great masters made use of this system, either to enlarge their own drawings (Michelangelo in the Sistine Chapel) or to copy images directly from photographs (Gilbert & George, Warhol, Dalí).

Aids for Sketching

Combined with an artificial model, a photograph can serve as a useful aid for sketching. A photograph enables the artist to represent the figure from a single viewpoint, capturing the precise movements made by the model. Using a mannequin helps to introduce a third dimension to this flat image. The photographic model can be improved and developed by sketching rapidly from the artificial model. This technique will thus allow the artist to achieve a more complete figure.

An Archive of Images

Images for working on figures do not necessarily need to be taken from real life; you can build up a good collection from magazine cutouts of both nude and clothed figures, as well as figures in motion. Building up a good image archive is not difficult—it merely requires time, organization, and patience. Personalizing your collection is very important. To this end, you can use an accordion-type folder and organize your images by subject—for example, figures walking; seated or reading male figures; male nudes; female nudes, and so on.

Photographic Models and Grids

When using a photograph, you must know certain techniques (which, in fact, were once used for copying) in order to enlarge the image of the model. These techniques will allow you to reproduce exactly the proportions and details of the original model.

The grid technique consists of dividing the model using equidistant, parallel lines, both vertical and horizontal, to produce a perfect grid. The smaller the squares, the more exact the copy. Another grid is then drawn on the picture, with the same number of squares as those on the model. The size of the squares will determine whether the copy is reduced or enlarged.

To make the drawing, simply choose one of the squares from the model and look for the matching square on the paper. Draw that section and extend the lines into the neighboring squares.

Using a live model for the pose allows us to experiment with the effects of light on the anatomy.

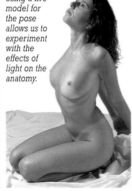

MORE INFORMATION
• The figure and color ranges, **p. 24**
• The figure as a method of study, **p. 28**

COMPOSITIONS WITH THE FIGURE: STILL LIFE

There are many compositions that can be developed using the figure as a starting point. The figure may appear in any kind of painting, integrated quite naturally into the scene as one of the elements of the work. In such cases the figure is not necessarily the center of interest but simply functions as part of the whole composition. As a result, the figure may be included in many types of paintings in varying degrees of importance.

Still Life and the Figure

Still life often offers an opportunity to incorporate the figure into a painting, as either a minor or a major element in the composition. It is important to remember, however, that if the figure is a major part of a still life, the center of interest will then be focused on the figure, rather than on the still life. How the figure is represented should be in harmony with the style of the painting. A representational, realistic painting should include a representational, realistic painting of the figure in that setting, developing the whole by harmonizing color, light, and shade.

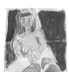
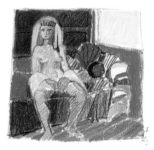

When placing a figure among different objects, composition becomes very important. Several studies of the most interesting compositions can be made, as you can see from these examples taken from sketches by Muntsa Calbó.

Charles Reid, Composition with Figure and Objects. Comparison between the final version and two alternate compositions.

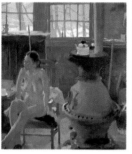

Integrating the Figure into the Composition

Special attention should be paid to the way in which the figure is integrated into the composition once the figure is not the only element in a painting, but only one part of the whole. The spatial relationship between the different elements of a painting is extremely important. The use of color is one of the most important elements in integrating and relating one object to another in a composition.

The initial integration of the figure into a composition begins with a rough sketch in which all the forms and shapes of the subject matter is blocked in. It is advisable to sketch a variety of possible compositions on inexpensive paper, in working out a final drawing.

From Still Life to Everyday Scenes

With Albrecht Dürer (1471–1528), still life painting became established as a pictorial genre per se. However, the tradition of depicting everyday scenes composed of both still lifes and figures involved in a single activity has survived down to this day. This ambiguous genre is still developed in the works of many artists.

*Jan Vermeer,
The Lace Maker.*

The Ambiguity of the Theme

Combining objects with a figure painting or introducing a figure into a still life creates a certain thematic ambiguity. The artist must thus find an appropriate balance between the importance attached to each of these elements so that the painting does not become monotonous. This is achieved by using a rhythmic composition of the forms appearing in the picture.

Light: Highlighting the Figure and Objects

One of the most useful techniques for merging the figure into the surrounding objects is to highlight various areas, such as those on the figure's skin, clothes, and nearby objects. The intensity of the light projected from a fixed point in the

painting can be determined and used as an integrating factor. The light falling on the objects can be directional, that is, coming directly from a light source or reflecting off other objects. These two different ways of treating the light can completely transform a picture, so that in the case of a still life with strong directional light, shadows will be cast on both the objects and the figure.

The light falling upon the model should be considered as a separate compositional feature of the picture; color is also a major element. In this watercolor painting, the light projecting on the figure and object are intended to create a chromatic balance.

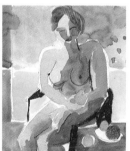

Figures and Objects

A certain spatial rhythm should animate the different objects in a still life. When a figure is introduced into a still life, the initial structure should consider the relationship between the figure and the objects. The viewer of a picture is uncon-

Compositional analysis of Pink Nude, *by Matisse. The balance between the figure and the object is perfect, due perhaps to a careful use of the Golden Rule.*

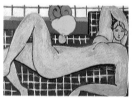

sciously conditioned by the sensation that darker objects—that is, denser colors—"weigh" more heavily than others. So within the relationship between the figure and the objects, the darker tonalities act as weights that must be balanced overall.

MORE INFORMATION
• Relationship between the background and the figure, **p. 32**
• Composition and the golden rule, **p. 46**

COMPOSITIONS WITH THE FIGURE: LANDSCAPE

While Romanticism revealed the relationship between Man and Nature, the relationship between figure and landscape had previously been used extensively in all pictorial genres. After Romanticism, subsequent movements like Impressionism and the various avant-garde movements produced a series of works well worth studying, where Man merges with Nature.

The Figure in the Urban Landscape

The figure that appears in an urban landscape must be adapted to its surroundings, emphasizing its presence by its positioning on a given picture plane and within the accompanying landscape. The situating planes in an urban landscape are extremely important, as they can be developed by superimposition or by the use of perspective. In both cases the figure will be reduced,

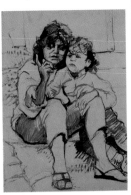

Drawing of a figure and background, coloring the darkest planes.

The subject is painted with flat brushstrokes, bringing out a contrast with the background. The background, here a short flight of steps and stones, should be situated in the correct plane.

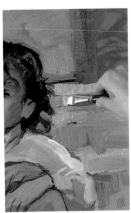

according to the plane it occupies. In this manner, a series of situating planes are established, defined by the size of the figure or the context in which it appears.

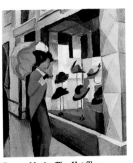

August Macke, The Hat Shop. The figure stands out by its position in several planes and by its chromatic effect.

Degrees of Importance

The figure appearing in a landscape may be reduced to a secondary element or share the same importance as the landscape itself.

This figure may be of a purely anecdotal nature and fall outside the main lines of the picture or, on the contrary, it may stand out from the vari-

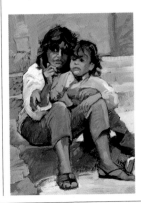

Compositions with the Figure: Still Life
Compositions with the Figure: Landscape
The Figure and Color Ranges

23

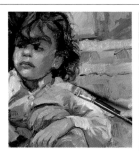

The treatment of the figure and the background should be balanced and show the same degree of synthesis, although the definition of the forms may vary. The contrasts of the figure are more pronounced.

ous planes of the landscape. This can be achieved by situating the figure within the main lines of the composition.

The Schematic Figure

The way the figure is treated in the picture will depend on the emphasis we intend to place on it. If the figure is shown in the distance, as a point of reference, both its forms and color will be treated in a schematic manner. Just a few brushstrokes may be enough to represent a figure in the landscape. Such figures do not need to be preplanned; they can be added at any stage of the development of the work.

Drawing directly with pen and ink. Landscape and figure are the only elements present.

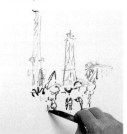

Free Interpretation

The form in which the figure is represented in a landscape does not necessarily have to abide by academic standards or follow the trends set by 20th-century avant-garde movements. A free interpretation can combine the figure and the landscape using new forms of expression.

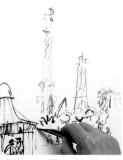

Planes are differentiated by their position, size, and the intensity of the grays.

The Figure and the Use of Color in Landscapes

The effect of color in a landscape influences equally the treatment of the figure as much as the landscape itself, as the entire picture receives the same amount and quality of light throughout. The range of colors the artist chooses for developing the forms of the landscape should be the same as that selected for the figure.

The Synthesis of Forms and Their Integration into the Picture

If the figure is important, integrating it into the landscape should be taken into account when carrying out the initial blocking in and sketching. When establishing the scheme for the main lines of the landscape, the artist must include the figure from the beginning. The linear outline of the form must be followed in such a way that it includes the essential information about the forms of the figure in the landscape.

MORE INFORMATION

• Proportion and placement of the figure in perspective, **p. 12**

A synthesis of the figure is essential in this kind of sketch.

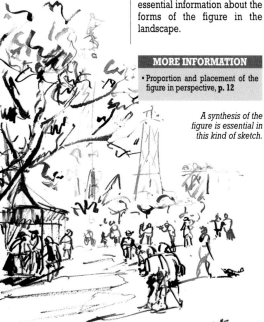

THE FIGURE AND COLOR RANGES

Harmonic ranges depend upon the "temperature" of the chromatic range used, and determine whether the palette is cool, warm, or neutral.
In the pictorial representation of a figure, the chosen range of colors is decisive for developing the picture and integrating the figure. In fact, the same form can produce completely different results depending on the range of colors selected.

Flesh colors in oil paint.

Flesh colors in watercolor.

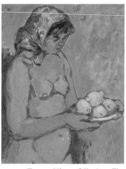

Teresa Llàcer, Offering. The dominant cool range chosen in this work uses complementary colors to produce a contrast between the two planes of the figure and the background.

Flesh Color and Harmonic Ranges

Flesh color as such does not exist. It is determined by the light falling on it and by the chromatic range used in the picture.

A chromatic range can be obtained by choosing, for example, colors that are considered cool (blues, greens) or by selecting warmer colors (earth tones, reds, and orange). It is also possible to create a palette that combines both tendencies to produce neutral colors. These are achieved by mixing unequal amounts of two complementary colors and adding a small quantity of white.

Cool Colors

Cool colors go from greenish yellows to the complete range of blues to greens and to violets. Any color range can be used for figures, including adding a dominant cool color to a warm palette to lend the entire range a cool tendency.

Color range of cool colors.

By choosing a cool palette, we are creating a feeling of light that brightens the figure. The rest of the painting must be treated accordingly with the same palette. This does not mean excluding warm colors entirely, but they should be given cool hues. Using a cool palette is simple, yet the painter must be careful when trying to add a cool note to warm colors as there is a risk of neutralizing the colors.

Warm Colors

In the same way, a warm palette can give rise to a series of harmonic ranges determining a visual gradation among the colors of a painting.

Colors from
the warm
range.

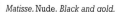

Flesh tones
from the
neutral range.

The harmony among warm colors is obtained by properly combining earth tones (browns, ochers, rust colors) and reds, including crimson, orange, and yellow.

A warm palette is ideal for painting a figure under a strong, natural light, although it can also be used to create a figure in an interior illuminated by a warm source of light, such as a fire. In this manner, an effect of "chiaroscuro" may be achieved.

Short process showing how the warm range may be applied to the figure.

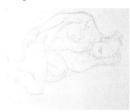

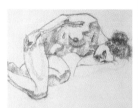

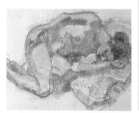

Neutral Colors

Neutral colors are neither warm nor cool. They are produced by mixing two opposing primary colors to which some white is added. The colors of the neutral harmonic range have a grayish tonality as the white lends them a "dirty" hue. It is, perhaps, the simplest of the harmonic ranges to use, since a color can easily be made neutral by adding a small quantity of its complementary color. The "dirty" hues of a figure painted in the neutral range allow it to blend easily into the context of the painting, even when its palette differs radically from the colors of the work.

Matisse, Nude. *Black and gold.*

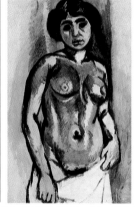

Van Gogh, Portrait of Father Tanguy.

Van Gogh's Figures

Van Gogh's work is constantly referred to as its radical approach contains excellent examples of the treatment of form and color. In his work, the treatment of the cool and warm palettes used to produce forceful portraits is clearly visible. Using either kind of palette, van Gogh effortlessly introduces colors from opposing palettes, taking advantage of the law of contrasts that states that a tone appears lighter when placed next to or surrounded by darker ones.

MORE INFORMATION
- Flesh tones and light, **p. 26**
- Flesh tones in figures, **p. 44**
- The figure in painting and drawing, **p. 66**
- Tonal gradation and use of color in the figure, **p. 84**

FLESH TONES AND LIGHT

In figure painting, the use of flesh tones and light give rise to the most striking pictorial effects. Oil paint is better suited than any other pictorial means for rendering flesh tones so that a solid knowledge of this technique is essential for representing figures. Areas of light are contrasted with shadow, and give flesh tones their correct hues. By studying the works of the great masters, we can appreciate the different ways flesh tones are achieved through the use of light and color.

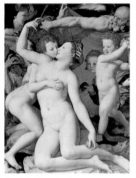

Angiolo Bronzino, Allegory of Love.

Flesh Has No Color

The color of flesh is the color of the light that falls on it. It is true that the melanin in the skin gives it a lighter or darker tone. However, even this pigment

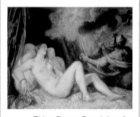

Titian, Danae Receiving the Golden Rain.

color can change completely depending on whether the light is white or orange, for example. It all depends on the colors you use. A white, luminous skin color can be achieved with a greenish tone—provided the rest of the colors used in the painting belong to the same chromatic gradation.

Light and Flesh Tones

The light source is always the lightest tone in a painting; any other colors will always be darker. Flesh colors are subject to this rule and the manner in which they are gradated serves to define their volume. Flesh tones also vary according to the direction of the lighting. An arm, for example, may be illuminated from the side, and the color of the flesh will change to create the illusion of volume. The purest colors are found on the surface most directly exposed to the light.

Shadow and Light in Figures

A figure, when sketched in, entirely lacks volume and is simply a contour outlined on a plane. As color is added, the

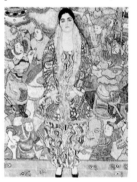

Gustav Klimt, Portrait of Freiderike Maria Beer. *The frontal lighting of this portrait eliminates almost all volume.*

darker areas of the forms are indicated, in this way modeling the different volumes. The figure develops in accordance with the volume created by the use of light.

Modeling the figure consists of representing its forms through a studied use of light and shadow. Modeling starts by situating the different planes of shadow in order to create different planes of values.

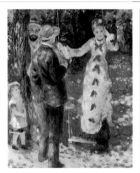

Auguste Renoir, The Swing. *The Impressionist Renoir masterfully represented the light filtering through the branches and leaves.*

Teresa Llácer, Nude.

Flesh Tones in Fauvism

Fauvism is characterized by the use of pure color, which produces striking flesh tones. However, the result is harmonious as these same colors are applied throughout the painting.

Different Types of Lighting

The color of flesh is directly dependent on the variations of light. If the light strikes the figure in a straight line, it fades in intensity as it meets the various planes of the figure, producing shadows when the volume changes planes. If the light is reflected, it becomes more diffuse and softens the effect of the shadows. If the lighting of the figure is frontal, from the artist's viewpoint, the shadows will disappear, and the tone of the model's skin will become purer.

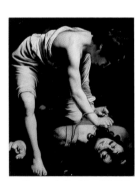

Caravaggio, David and Goliath. *Here, maximum use has been made of the contrast between light and shadow. Note the flesh tones of the middle as well as the most luminous points on the skin.*

MORE INFORMATION

- The figure and color ranges, **p. 24**
- Flesh tones in figures, **p. 44**
- Light and shadow in the figure, **p. 68**
- Tonal gradation and use of color in the figure, **p. 84**

Pictorial Media and Flesh Tones

Each pictorial medium allows for a different approach for the flesh tones, depending on whether it is wet or dry, its drying speed, and its opacity. Flesh tones depend entirely on light. Consequently, when using watercolor or colored pencils, the artist must always leave blank the lighter areas corresponding to the highlights of the skin. From these lighter tones, darker colors are then added. By contrast, opaque media such as pastels allow the artist to superimpose colors and obtain a wide variety of tones without having to mix colors. Flesh colors in pastels can be achieved by applying the middle tones first, then the shadows, and finally the points of maximum brightness.

Two poses with direct and side lighting.

In these two poses, the light is indirect, that is, reflected.

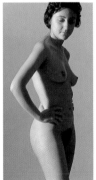

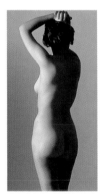

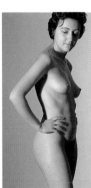

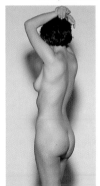

THE FIGURE AS A METHOD OF STUDY

Studying the figure, both in drawing and in painting, is one of the most important exercises any artist can do. Based on a full knowledge of the human body, forms in painting can be developed in many different ways.

Studying the figure not only involves a knowledge of anatomy but also of how to represent volume, space, and the different approaches suggested by the subject.

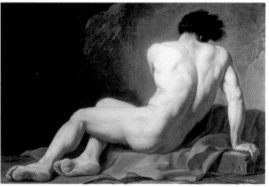

David, Nude Study of a Man called Patroclus. *The nude study emphasizes the anatomical model from the viewpoint of tonal gradation.*

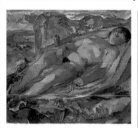

Albert Weisgerber, Woman Lying in a Mountain Landscape. *This study of anatomy focuses on the application of colorism.*

Anatomical Study

Anatomical drawing differs from the study of poses in that it concentrates on the arrangement of different parts of the body, with their bone and muscle structure, in order to analyze the possibilities of movement.

Anatomical studies analyze the different proportions of the figure from a strictly scientific point of view, though an anatomical drawing can be enriched with artistic details, such as the modeling of forms. These additions must, however, help to understand the play of the anatomy under different kinds of light and in various types of movement.

Drawing and Pose

The study of the pose is another way of treating the human figure as a pictorial theme. Because the model occupies a space very similar to the placement of the figure within the composition, the pose remains the basic reference point for all artists studying the human figure.

The treatment of the pose requires a previous study of figure drawing. The anatomical knowledge of the figure is then expressed in a more artistic manner.

The pose enables us to study the body in a wide range of different positions, including the suggested movement of the figure itself, giving rise to foreshortening, *contrappostos,* as well as standing, seated, or figures lying down.

Once the figure has been drawn, the first values are indicated and the areas of maximum light and shadow are identified.

The study of anatomy is complemented by the modeling of the figure.

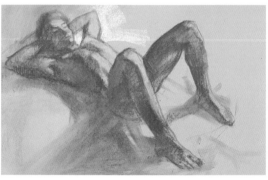

Flesh Tones and Light
The Figure as a Method of Study
The Figure as the Main Theme

29

Background and Figure

One of the major problems in painting is to establish the relationship between the background and the figure. Though it may not seem important at first, in practice, establishing limits between them and applying several basic rules will ensure a correct representation of the figure.

The main figure should relate to the picture's center of interest and this, in turn, depends on the way the picture is framed. If the figure is to be treated in a basic manner, the background will require an even more basic treatment.

In this work, the artist used a negative technique—reserving white areas to create the figure and integrate it into the background.

The effect of alternating eraser and charcoal on the background suggests the relationship between the figure and the background.

A Perfect Study

To fully explain the execution of a study is a complex task. We cannot reduce it to a series of independent studies of form, values, or color, but merely acknowledge the fact that it encompasses all three simultaneously. It includes blocking in, a study of proportion, measurements, and the relationship between the figure and the background. The works of great masters such as Michelangelo and Leonardo reflect these rules in the treatment of even the most insignificant details.

Michelangelo,
The Burial of Christ.

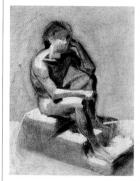

Proportion and Framing

The proportions between the figure and the other forms in the picture should be coherent. This means that not only the proportions of the figure itself should be correct, but also those of the space surrounding it in the picture. This point does not concern the model so much as the spaces between it and the edges of the painting.

Calculating the Measurements of the Figure

When making a figure study, another determining factor is to establish its different measurements in relation to the composition and the frame, as well as its body measurements. This calculation is closely related to the placement of the figure in the painting. This process allows for an emphasis on certain parts of the body more than others.

MORE INFORMATION

• Poses: *contrapposto*, **p. 10**
• Obtaining the proportions of the figure, **p. 14**
• The parts of the body and the sketch, **p. 16**

The blocking in of the figure is closely related to the calculation of its measurements. The best method for drawing the forms is to start from a geometric scheme.

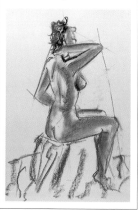

THE FIGURE AS THE MAIN THEME

A painting acquires specific connotations when focusing on a figure, yet there are many ways to introduce the figure within the main theme of a painting. The way in which the figure is treated defines the pictorial style the artist has chosen, as figures are not always represented in a realistic fashion.

Portraiture is one of the most inspiring figure themes.

Realistic and Nonrealistic Figures

Whether the figure is developed in a realistic or nonrealis-

Realistic figurative treatment. Despite the emphasis on lines and forms, a direct relation to reality can be seen.

Themes

The theme of the figure is so varied that it encompasses all pictorial genres to some extent. Figurative painting includes portraits, everyday scenes, figurative still lifes, nudes, and a few landscape compositions. Whenever a figure is the main theme of the work, the way in which it is represented corresponds to the medium used. In general, however, artists chose between two basic types of expression: the realistic figure and the abstract figure.

Treatment in Plastic Media

The different pictorial means at the artist's disposal cover the entire range of plastic, or three-

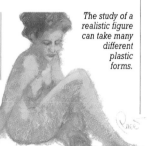

The study of a realistic figure can take many different plastic forms.

dimensional, possibilities for the treatment of figures to such a degree that different pictorial styles have even developed from the use of those various media.

Expressionism was not only a return to the primitive figure, but also an attempt to free the figure from an established formalism. The line, expression, and texture became prominent in media such as oils and acrylics, and revealed an aesthetic value that had not been fully appreciated until that time.

tic form depends on the artist's intention. However, any image of the human figure must, of course, bear some resemblance to certain basic reference points, even though it is seen by the artist as a different object.

MORE INFORMATION

• Relationship between the background and the figure, **p. 32**
• Figure and abstraction, **p. 48**

The Figure as a Method of Study
The Figure as the Main Theme
Relationship Between Background and the Figure
31

Carrá, The Knight from the West. *Here you can observe the effect of the lines directing attention toward the figure's points of interest.*

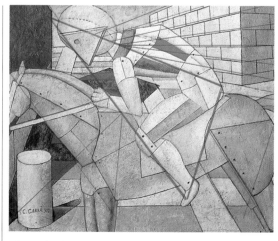

Short sequence in the development of a nonrealistic figure.

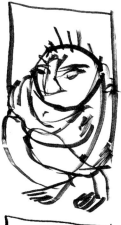

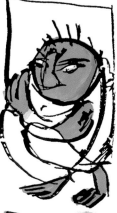

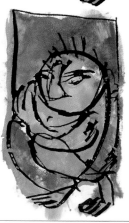

The Main Points of the Picture

In any kind of representation where the figure plays a central role, it is essential to direct attention toward the figure's main points by means of invisible lines that are planned when starting the picture, although they can also be introduced as the picture develops.

Situation and Composition

In the composition, the figure may shift through several points, or centers, while still playing a central role in the picture. The position of the figure within the composition should be clearly defined within the basic scheme—that is, if the composition is predominantly vertical, the lines of the figure should be oriented in a different direction. This differentiation may also be achieved by using chromatic and tonal changes.

Matisse, Odalisque in Red. *This composition positions the figure on a plane that slants away from all the others.*

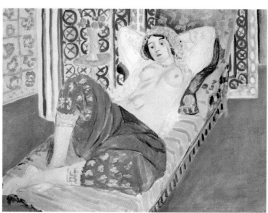

RELATIONSHIP BETWEEN THE BACKGROUND AND THE FIGURE

When representing a figure in a painting, it is as if the two main elements, the background and the figure, were fighting for the space available.
There should be a harmonious relationship between the background and the figure, with neither dominating the other. A figure occupying most of the space in a picture should not be set against a dark, oppressive background, for example; the figure and the background should be separated by visual planes that add texture.

Here you can see how a change in focus transforms the background and the role played by the figure.

Purpose of the Background and Space for the Figure

The figure relates to the background in two ways. On the one hand, there is a direct relationship between the figure and the background that can only be modified by a change of frame or lighting that affects the different planes of the figure and the atmosphere around it. On the other hand, the artist may chose to establish a specific relationship between the figure and the background in the painting. This choice is linked to the atmosphere of the work.

The figure may appear to be "fixed" against the background or separated from it; in either case, the result will depend on how the model was initially placed within its framework.

Atmosphere and Background

In a figure painting, the atmosphere is one of the main ways in which the different planes of the composition can be merged together. Sometimes there are no planes separating the figure from the background. In this instance, an atmospheric effect can help to create volume and separate the figure from the background.

In this drawing the separation between the background and the figure is uncomplicated.

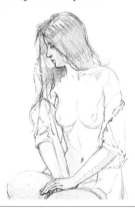

The main requirement of all realistic representations is to start from a perfectly well-defined figure. The darkest planes of the figure can then be added to the drawing using the chosen color range. If a mono-chromatic range is used, this effect will be produced by using contrasting tones between the background and the figure.

After completing the darkest areas of the figure, an even darker tone is added behind it to make it stand out.

Chiaroscuro as a Solution

Depending on the chosen approach to a picture, the planes between the figure and the background can be differentiated by using various types of light, contrasting the lightest areas with those in dark shadow.

This method, among others, allows the artist to both merge the figure with and separate it from the background. In this work, the chiaroscuro effect is

The Figure as the Main Theme
Relationship Between the Background and the Figure
Two Painting Styles

33

The darker tones are placed next to the points of maximum brightness.

In this example, the figure stands out against the background because the compositional lines of the painting direct attention to it.

achieved by placing the darkest colors of the background next to the brightest point of the figure, thus sharpening the contrast.

The dark tones of the background help to merge the figure into the picture.

The Figure and the Compositional Planes

Although the figure should be integrated into the picture, it should, at the same time, stand out against the plane it occupies; that is, the background should never detract from the importance of the figure. Its main purpose is to bring together and complement the various elements of the composition.

The importance of the figure within the plane of the composition will be emphasized by the forms and lines defined by the other compositional elements of the picture.

MORE INFORMATION

* The figure as a method of study, **p. 28**
* Light and shadow in the figure, **p. 68**

Sketch and Background

Integrating a figure into the background can often be achieved chromatically from the initial sketch, with color then applied over the entire area of the picture.

The tones of the figure and the background were established in the initial sketch. This will help to further develop the work.

The use of simultaneous contrasts can be of great help in separating planes.

The Law of Simultaneous Contrasts

In order to differentiate the figure from the background, we must remember the law of simultaneous contrasts, according to which a light tone will appear much lighter when placed next to a darker one. In the case of color, this contrast can be produced by juxtaposing complementary colors.

TWO PAINTING STYLES

The use of color throughout the history of art can be divided into two main painting styles: classical painting and a coloring process arising from the first avant-garde movements toward the end of the 19th century.
Both concepts approach color in different ways and use their own standards and practices in order to apply color and create volume through the use of light.

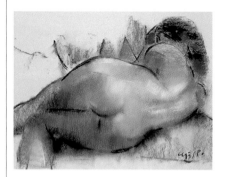

Image of a figure based on the method of tonal gradation.

Pastel colors organized according to a tonal scale suitable for modeling.

Principles of Tonal Gradation

The modeling of the figure is achieved through tonal gradations. Modeling consists of applying color in accordance with the amount of light falling on a given area, using a tonal scale directly linked to the base color.

In terms of tonal gradation, shadows are interpreted as the gradual darkening of lighter colors; the color of the shadows is not considered to be differ-

Colors that may be used in a colorist figure.

ent from the color of the object producing it, but corresponds to a tonal gradation of the colors.

The Colorist Concept

Since the Impressionist movement, color started to be used as a way to enhance forms. Colorism interprets dark tones as genuine colors of the figure itself, not as chromatic gradations. In a figure, therefore, the tone of an arm or leg does not gradate toward darker colors, but is transformed directly into a different color.

The shadows and the lightest colors are considered to be independent colors, working on the basis of complementary or simultaneous contrast.

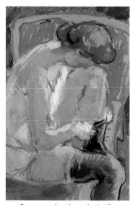

An example of a colorist figure.

Modeling a Figure

Pastels are ideal for modeling, although any pictorial medium may be used.

As is the case with all figures, the first requirement is that the drawing should separate the main forms; in this case, a dark tone is used for the background, while earth tones represent the flesh; darker tones are applied to the shaded areas and warmer tones to the

Relationship Between the Background and the Figure
Two Painting Styles
Interpretations of Figures: Illustrations and Comics

35

Two Ways of Interpreting Painting

There are no absolute rules concerning pictorial representation; the creativity of each individual artist may develop in different ways according to how the artist interprets painting. The use of values and a heavy reliance on color are two ways in which figures can be painted.

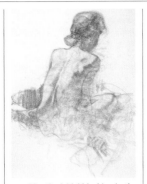

After the initial blocking in, the shadows are added with colors that do not correspond to the areas of light.

The Making of a Colorist Painting

A colorist figure starts with a fully completed drawing in which the shadows are already indicated, though not as a result of gradation but as areas with their own colors. In the same way, the areas of light are represented with pure colors that do not mix with the darker tones.

In areas where the light is less strong, the colors become darker but do not correspond to a tonal gradation. For example, if a lighted area requires a pale rose, its shadow may be painted in orange or in an earth color.

| **MORE INFORMATION** |

• Tonal gradation and use of color in the figure, **p. 84**

Direct application of colors.

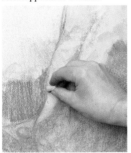

Finished version of a colorist work.

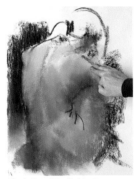

Gradation of the lighter tones.

highlights. The highlights softly gradate toward the shaded areas, except those that are sharply edged.

The result of tonal gradation.

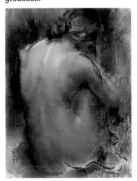

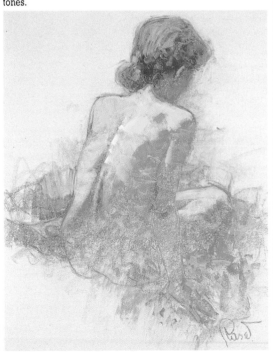

INTERPRETATIONS OF FIGURES: ILLUSTRATIONS AND COMICS

Using figures in comics and illustrations requires a broad knowledge of anatomy, even when producing caricatures or distorted forms.
The figure plays an important part in comics and illustration as usually the narrative success depends on it.

Drawing is fundamental to interpreting figures in comics. Here you can see how their structure actually conforms to the classical representation of figures.

The exaggerated movements and gestures of the figure is one of the most characteristic features of this type of drawing.

The Figure in Drawing

The drawing of caricatures requires the same basic techniques as any other form of artistic representation and interpretation. Drawing is common to all art forms and should never be underestimated. To produce a caricature is, in fact, impossible without a thorough knowledge of drawing techniques.

The figure, both in illustrations and in comics, is usually a basic representation, using the least possible number of lines to express proportions and movement.

The proportions of the figure increase in the areas that are to be emphasized, although even these are based on a prior structure that can be developed to create the figure in movement.

Exaggeration

One of the most characteristic features of this type of drawing is the exaggeration of both the figure and its movements. A real model or a photograph can be used at first to capture the main forms of the drawing. Later, these forms can be transformed creatively by the artist, deforming or exaggerating the figure's features in a humorous manner.

This illustration of children shows a simple figure with rounded forms.

MORE INFORMATION

• The parts of the body and the sketch, **p. 16**

Two Painting Styles
Interpretations of Figures: Illustrations and Comics
Different Ways of Framing the Figure

37

Practice and Technique

Practice is the key to acquiring technique in drawing illustrations and comics. It is particularly important to study the illustrations and drawings of professional artists, which will also enable you to judge their work better and perhaps acquire a taste for a certain drawing style.

Illustration for adults by Pedro Rodríguez.

The Artist and Technique

Style comes to an artist as his work matures, as we can see in the case of Pedro Rodríguez. A profound knowledge of human anatomy combined with an endless imagination are the keys to Rodríguez' biting and ironic art. To create his distorted figures, the artist did not use a model—just different attempts, sketches, and… experiments.

Pedro Rodríguez. Illustration using a combined technique.

Suggestion of Movement

In addition to the exaggeration so characteristic of comic drawings, the movement of the figures is also treated in a specific manner; it is suggested by means of the figure's pose.

The pose should be slightly exaggerated, increasing the curve of rounded forms and thus suggesting an overexpressiveness that this type of work requires.

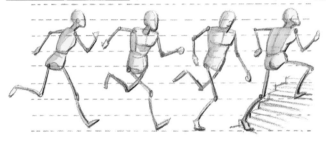

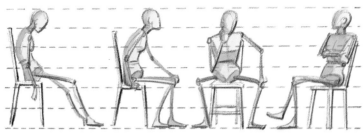

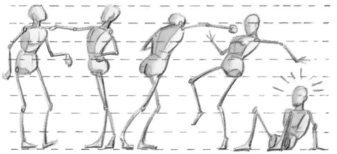

Sketches for possible poses. The movements of a caricature should be exaggerated versions of real movements.

DIFFERENT WAYS OF FRAMING THE FIGURE

Framing is the process by which the artist decides which part of the model to represent in the picture. As we see it in real life, a figure can be represented within many different frames. If a picture uses more than one frame, they become planes that suggest depth. A figure can be painted using many different frames, as does the human eye. For the viewer, the largest masses and volumes of the figure will appear the closest.

The Plane and the Frame

The plane is the spatial area used to define the figure's proximity to the artist or the viewer. The frame is the part of the model that the artist decides to show in his work. As you can see, both factors play an important role in representing figures, although both the plane and the frame should focus on the model.

In order to decide on a plane, the artist can use his hands to frame the model and select the image that most interests him. The number of planes will depend on the chosen frame, as a wide frame will always have more planes than a more restricted one.

A short frame or closeup.

A medium frame.

A wide frame.

Planes of Depth with a Single Model

To make a composition with figures, it is not essential to have several models; often one is sufficient. In this case, however, sketches are essential, as they allow you to vary the viewpoint of the model and repeat its form in the picture, drawing as many figures as are necessary.

Using these sketches, the figures are transferred to the drawing composition according to the chosen composition. In order to avoid densely crowded areas, depth should be added by using different planes. These planes are created either by superimposing the figures or by reducing the size of the most distant ones.

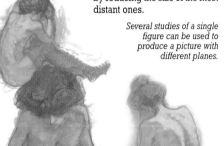

Several studies of a single figure can be used to produce a picture with different planes.

Interpretations of Figures: Illustrations and Comics
Different Ways of Framing the Figure
Postimpressionism, Expressionism, Realism

39

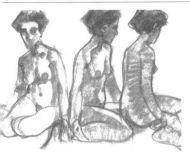

This sketch was drawn with a single model placed in different positions.

Layout of possible planes for a figure composition made from a single model, as sketched earlier.

MORE INFORMATION

• The figure as the main theme, **p. 30**
• Composition and the golden rule, **p. 46**

Framing and Composition

The composition is determined by the frame chosen for the picture. Depending on how this frame develops, the composition may or may not be correct. The main elements to be taken into account in the composition are the compositional lines and the different masses of color and tone. The distribution of these masses within the chosen format

A frame that explains very little. We cannot identify what the figure is doing and the background is unclear.

Framing in Contemporary Painting

From traditional painting to abstract Expressionism, the concepts of painting, color, and media have changed. Some other features of visual arts, however, have remained the same since the time of the Renaissance. Among them is the process of framing the figure and using different planes throughout the picture. Today, contemporary artists experiment with variations on this theme, seeking unusual shifts in the position of the figure within the painting.

is what gives the figure its importance in the picture. A faulty distribution of these forms may detract from the importance of

In this frame, the elements are well balanced and a rhythm is created between the main lines.

the main figure or cause the overall effect to lack interest.

Geometry in Space

Before actually placing the figures in the composition, it is advisable to arrange the different forms following a certain geometric order. Not only can the figures be reduced to geometric forms, but also the planes themselves.

The forms that develop within the area of the picture can balance the frame and the composition.

Ronald Kitaj, The Jewish Traveler.

Excessive use of symmetry produces a monotonous frame.

A geometric layout of the planes used in the frame by Ronald Kitaj. The figure in the background, with its diamond-shaped position, is used to balance the composition.

POSTIMPRESSIONISM, EXPRESSIONISM, REALISM

Throughout art history, the figure has been adapted to all pictorial styles and continued to play a central role in each of them. Each style takes on different connotations when treating the figure, depending on how the figure and the theme are related. There are, of course, cases where the theme determines the style to be used.

The Classical Study as a Basis

The basis of all artistic expression is the drawing. In order to produce works in various pictorial styles, however, it is necessary to acquire a classical background to act as a guide.

For both figurative and abstract representation, classical study is the basis of a sound knowledge of form, for if representing a figure realistically is difficult, it is far more complex to represent an idea in the artist's mind.

The Figure in Contemporary Art

In the history of art, the 20th century stands out as being the period during which the largest number of artistic movements developed. From the emergence of Impressionism to the end of the millennia, we have seen a dizzying succession of so called "isms," continuously overlapping various pictorial styles. At the end of the 20th century, no predominant tendency prevails, and figures are drawn and painted with suggestions of any of the past styles.

Academic Realism

The academic style encompasses a series of problems whose solution corresponds to advances in the art of representation. Learning how to draw academic figures is a slow process that requires great patience on the artist's part. However, daily practice and perseverance will produce positive results in the end.

Figure studies can be made anywhere, though it is always advisable to attend an art center regularly where models pose. Most towns have art centers of this type. They are usually inexpensive and allow you to compare your work with that of fellow artists and to benefit from the teacher's advice.

Academic blocking in develops the structures and forms of the figure in terms of their relative value. The sketched forms are then laid out following the rules of proportion.

From the sketch, the construction of the forms establishes the planes of light and shadow.

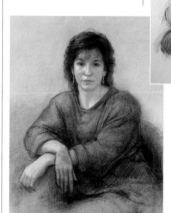

The addition of light complements the gradations with white highlights. The figure is completed with a detailed study of the proportions.

Different Ways of Framing the Figure
Postimpressionism, Expressionism, Realism
Modeling the Figure: Watercolor and Drawing
41

Postimpressionism and Changes in Perception of the Figure

The Impressionist revolution radically changed the way color and figures were perceived; modeling disappeared and gave way to colorism. In the colorist vision, all shaded areas of the figure were painted in different hues, which became colors in their own right.

Colorist works use pure color in the areas where modeling tonal gradation would have put shadows. The light falling on the figure is then suggested by the contrast of complementary colors and different tones.

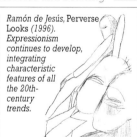

Ramón de Jesús, Perverse Looks *(1996). Expressionism continues to develop, integrating characteristic features of all the 20th-century trends.*

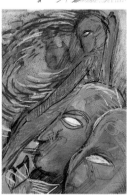

The Evolution Toward New Tendencies: Expressionism

Expressionism is one of the early 20th-century movements that most influenced contemporary artistic creations. The Expressionist figure tends toward exaggeration in its expression and color, yet still retains such important features as composition or the inherent aspect of form. Naturally, the Expressionist movement has changed over the course of a century, evolving toward pure expression, and in many instances eliminating form as such.

As we have seen, an Expressionist work is based, as are all other styles, on schema that are, in turn, based on drawing.

Pure colors are added to the blocked in figure, bright in the areas of light and denser in the shaded areas. The luminosity of a color is, of course, also determined by the color applied next to it.

Colors are used to define not only light, but also planes and volumes.

Colorism is the legacy of the Impressionists, Postimpressionists, and Fauvists.

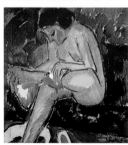

Karl Schmidt-Rottluff, Girl Washing *(1912).*

Ernst Ludwig Kirchner, Two Nudes with Tub and Stove *(1911).*

MORE INFORMATION

- The figure as the main theme, **p. 30**
- Relationship between the background and the figure, **p. 32**
- Two styles of painting, **p. 34**

MODELING THE FIGURE: WATERCOLOR AND DRAWING

Modeling is the system of representation used by artists to suggest a three-dimensional effect on a two-dimensional surface. The colors depicting volumes are not flat but change according to the type of light falling upon them.
The modeling of forms is particularly difficult to achieve when painting with watercolor. This is why this technique is so important to master. In watercolor, for example, white is never used; instead, the white of the paper is used as the basis for the lightest tones.

The Basic Technique

Watercolor, as its name indicates, is a water-based technique. When the paint is mixed with water, a wide range of tones can be obtained, from the deepest, pure color to the white of the paper barely tinged with a fine glaze.

Gradation is used to create different values of light and shadow. This technique helps bring out on paper the light of the various elements that, as we mentioned earlier, can always be reduced to geometric volumes.

A simple gradation. Once learned, this technique can be applied to any geometric element or to any figure.

The modeling of forms is achieved through areas of light and shadow.

Modeling by Absorption of Color

When the drawing is completed, an even wash is applied over the entire surface of the figure's body. This wash may cover the darker colors without affecting them, as it will not be visible.

Before the paint dries out, take a dry brush and absorb the paint from the areas that should be lighter. This way you will have two clearly defined areas describing a three-dimensional form. On this base different hues and tones may be added to accentuate the volume of the forms.

Paint is absorbed with a dry brush to lighten specific areas.

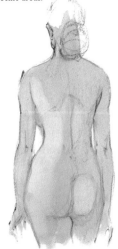

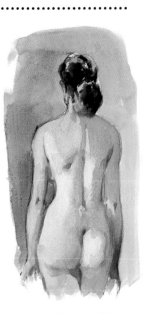

Over the resulting base, different hues and tones can be added while the paper is still wet.

Modeling by Gradation

When the form is perfectly defined, areas of shadow are added to the darker parts of the body, outlining the forms of the figure and creating a contrast with the areas of light.

Before the paint dries out, the shaded areas are gradated by using a large amount of water, thus completing the modeling of the figure. When the watercolor has dried, it can be retouched using new

tonalities, increasing the contrast where needed.

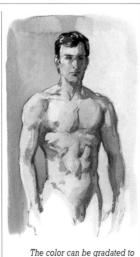

The color can be gradated to obtain different tonal shadings.

The lightest tones are painted with much water.

Before the paint dries out, the colors are gradated toward the lighter areas.

Outline of the basic forms with the main shadows.

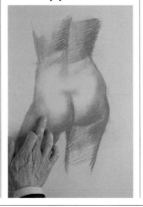

Blending the tones on the base color of the paper.

Shading and Modeling with Conté and Chalk

Planning a drawing is basic to constructing the forms of the figure. It establishes the outline to which the first areas of shadow can be added, following the plane of the forms of the body. These shadows are then gently smudged to blend with the color of the paper, or with the lightest tones.

The forms requiring a stronger contrast are accentuated and white is added and the fingers are used to blend the areas of bright light with the shadow.

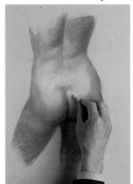

Adding white to the areas of maximum brightness.

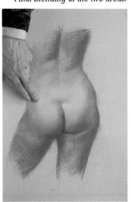

Final blending of the two areas.

MORE INFORMATION

• Obtaining the proportions of the figure, **p. 14**
• Two styles of painting, **p. 34**
• Shading in pencil, **p. 72**

FLESH TONES IN FIGURES

One of the main problems for beginning painters is to learn precisely how to paint flesh tones. You will see that it is not difficult when you consider that flesh has no color of its own; it all depends on the light striking the model and, by extension, the chromatic range used in the work.

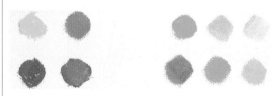

Neutral colors are achieved by mixing two complementary colors and adding white; a great many flesh tones can thus be achieved.

Neutral Flesh Tones

A mixed or neutral palette is useful when rendering flesh tones because its colors do not tend to either cool or warm, but can alternate between the two ranges.

A neutral palette is obtained by combining two complementary colors with a small amount of white. A flesh

Colors used in a neutral palette.

tone rendered with a neutral palette can tend toward cool or warm tonalities, depending on the chosen appearance of the figure. The chromatic ranges of the background against which the figure is set plays an important role in defining the final flesh tone. This chromatic harmony between the background and the colors of the skin can, for example, make a greenish tonality appear quite natural.

Warm Flesh Tones

The warm palette achieves chromatic harmony with a range of tones running from yellow to violet, and excluding any colors related to greens and blues.

The use of white must be avoided when working with a warm palette, as it tends to dull the colors, turning reds into pinks, for example, and actually reduces their luminosity. If a soft red is needed, it is always preferable to add a little orange-yellow;

and when mixing the color of a shadow, a dark earth tone or burnt umber is preferable to adding black.

In any case, using a warm chromatic range to paint flesh tones does not necessarily prevent the use of cool colors such as blue or green. Remember that khaki is a combination of red and green, and can often be used to render the darker areas of the skin. Introducing cool colors to a warm palette balances any excessive color, producing a more harmonious result.

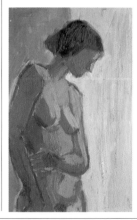

Palette of warm flesh tones with a cool tendency.

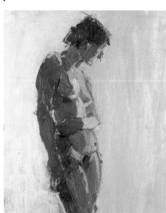

Modeling the Figure: Watercolor and Drawing 45
Flesh Tones in Figures
Composition and the Golden Rule

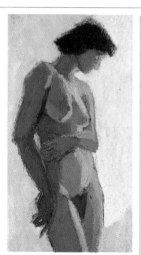

The palette has become richer; the contrast with the orange tones makes the earth tones appear warmer.

Cool Flesh Tones

The cool palette includes tones ranging from yellow to violet, as the warmest.

The true colors of the cool range are blues and greens, yet when painting a figure, the artist should not limit himself to this range but should enhance it with warm hues. By doing so, the orange ochers will have a warm note which will offset any excessive coolness conveyed by the blues and greens.

Flesh Tones in Rubens' Work

Rubens' work is characterized by very luminous flesh tones. However, the master did not believe that a specific flesh tone existed as such and once said: "Give me mud and I will paint a Venus." He could indeed have done so, provided he was able to add his own colors to the chosen range.

Rubens' theory is entirely correct. Colors work in ranges and light affects not only the figure on which it falls but also the surrounding area. As a result, the entire painting should have the same chromatic range.

Peter Paul Rubens, The Rape of Leucippus' Daughters.

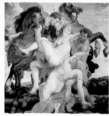

A figure painted in predominantly yellow-green colors.

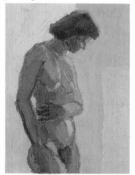

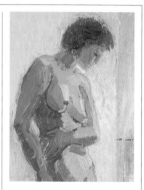

This time, the dominant cool palette is broken by the mixing of yellow and blue.

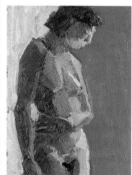

A given chromatic range may include tonalities from other ranges, as is the case here where warm tonalities have been added.

COMPOSITION AND THE GOLDEN RULE

Throughout history, one of the main goals of artistic creation, up to Abstract Expressionism, has been to find a balance between the figure and its surroundings. In a composition, the artist seeks to create a sense of harmony between the different elements of the painting. At the time of the Roman Empire, a mathematical formula was used to divide the space of the picture in order to produce a perfect composition (this formula was later recovered during the Renaissance). This so-called *golden rule* served as a compositional guide throughout art history and is still used today, consciously or not, by many artists.

There are endless compositional possibilities to be developed when the standard points have been found.

The Golden Rule Applied to Figures

The golden rule is easy to apply to divide up the composition. It is obtained by multiplying the length of the picture by 0.618. The number obtained becomes a standard measurement that can be applied to the width and length of the picture to locate a standard point. When different parts of the figure coincide with these points, the result is a balanced and harmonious composition.

Classical Composition in Modern Painting

Some permanent features seem to appear repeatedly throughout the history of art. For example, the rules defining the composition of space, especially in figurative representations, conform to aesthetic ideals that have survived since the quattrocento. The method of balancing the composition still relies on the calculations of the standard section. In fact, the artist does not need to make those calculations, since the composition usually follows the golden rule intuitively. It is, nevertheless, interesting to note that this rule was consistently applied to most great paintings.

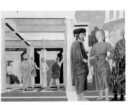

Piero della Francesca, The Flagellation of Christ.

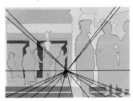

A study of the perspective of the composition in Piero della Francesca's work.

Composition and Perspective

While the internal composition of a work takes into account the placement of the various figures on different planes, perspective is also a determining factor for locating the centers of interest. If the figures or groups of figures have been placed according to the lines of perspective, the distribution of the figures around the vanishing point can be moved away from the arithmetic center of the picture and extended along the lines of perspective. In other words, the weight of the figures in the composition can be altered provided they follow the lines of perspective.

Raphael, Sistine Madonna.
In this work, all the figures are distributed in accordance with the standard sections.

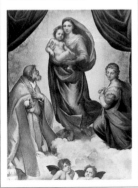

Edward Hopper,
Eleven A.M.

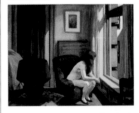

Sketch of the standard points applied to Hopper's work.

Advice on Composition

As we mentioned earlier, it is not necessary to carry out mathematical calculations to set up the composition in a painting. However, if a geometric scheme is used, the figures will be more successfully distributed.

Also, the sketch leading to the standard section is always synonymous with balance. It is a good idea to make several tests on a piece of paper to see how these sections fit a certain format. The standard section not only gives the location of the figures but also establishes the points and intersections between the forms or limits to the different areas of the picture.

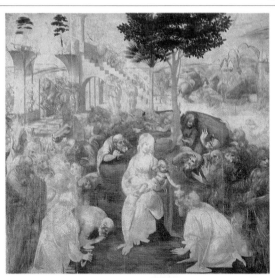

Leonardo da Vinci, The Adoration of the Magi. *In this work we can see a triangular composition within a study based on the standard number used to divide the space and establish the main points.*

MORE INFORMATION

- Proportion and placement of the figure in perspective, **p. 12**
- Different ways of framing the figure, **p. 38**

Raphael, The Veil, *and its compo-sitio-nal study.*

Classical Composition

Of all the compositional projections used in figurative representation, only the triangular outline has survived all the pictorial styles and fashionable trends to the present day. Compositional forms always tend to follow a geometric scheme, and if you closely observe the internal composition of many classical works, you will see that their main composition is triangular in shape.

Composition and Format in Ingres's Work

The problems of composition occasionally give rise to historical anecdotes. Among them is the story of the continuous format changes made in Ingres's painting, *The Turkish Bath*. At first, this work did not have the circular format that we know today. Initially it was rectangular and the figure seen from the back was represented in the foreground. The artist then added lateral margins to enlarge the format and ultimately decided that the best shape for the chosen composition was a circular one.

Ingres, The Turkish Bath, *as we know it today.*

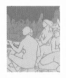

The original format of The Turkish Bath.

Enlargement of the original format.

FIGURE AND ABSTRACTION

The first abstract figure in painting was found in Cézanne's work.
His breakthrough was subsequently followed by Picasso's Cubist style.
Since the creation of *Les Demoiselles d'Avignon*, the process of abstraction has
undergone many changes of style.

The Figurative Referent

The representation of a figure, or of any other element in nature, has at its base geometric forms. The artist can then establish the main lines that will determine the different parts of his figures' bodies. But he must take into account a series of factors that help to calculate the distances between each form of the figure, especially when the abstraction is based on a figurative referent. The referents should be understood and clearly positioned by the artist on the canvas, even if they are to be distorted or abstracted at a later stage.

A real model or a photograph can be used.

The Model as a Pretext

Very often, a real model providing a direct source for the forms and colors represented in a drawing or a painting is necessary to produce an abstract work. This is not pure abstraction, of course, but a variation on reality. On other occasions, however, the model is merely a pretext, and in the final result the figures are not representative but have become mere plastic elements within the painting.

A composition with a figure as the subject is a source of great potential. Should the figure be merely a point of reference, this creativity can be freely developed in order to analyze any feature that depends more on the painting itself than on the figurative reference.

In this case the model is the same but is used merely as a pretext for an abstract composition.

MORE INFORMATION
• The figure as a method of study, **p. 28**
• Painting and synthesis, **p. 92**

In this example you can see the figurative references in the construction of an abstract work, which in this case is a simple matter.

Example of an abstract work based on a figurative element.

A drawing is the basis for any subsequent work.

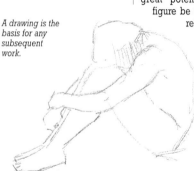

Primitive Art

Abstract painting can often express feelings that cannot be conveyed by a classical mode of representation. Movements such as Expressionism have their roots in primitive art. Primitive artists, in fact, used a totally expressionist art which has inspired the great majority of present-day art movements.

Ramón de Jesús, Portrait 39 *Oil and wax on paper.*

Abstraction and Reality

Two entirely different methods can be applied to the creation of abstract figures. One is

In the abstracting process, the attention may be focused on any of the real model's features.

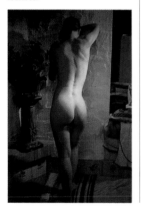

Developing the forms in sketches helps to guide the work, as in this case with the effect of highlighted forms.

the result of a careful study of form, light, and color. The other consists of abstracting these characteristics, leading the artist to select certain features of the figure and develop them, leaving out other possible elements of reality. If a real model is used, many possibilities of development exist. However, the artist should start from a concrete element, such as light, for example, leaving out other referents, such as proportions and modeling.

Developing the forms in sketches helps guide the work, as in this case with the effect of highlighted forms.

The same modeling process can be achieved with color, concentrating on the areas of light and shadow.

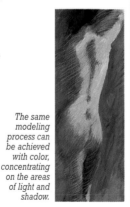

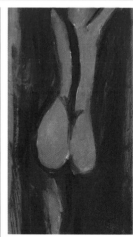

The previous image can be used to develop new images and abstract forms.

Possibilities and Means

An abstract figure can be represented in a multiplicity of ways and media. From the classical methods to the most advanced techniques such as computer graphics or photocopy reproductions, all media are perfectly adapted to the creation of an abstract figure. We must rid ourselves of the taboo of abstraction as a style reserved for a knowing elite. Rather, it should be seen as a playful and different expression of reality.

GESTURES

Gestures are one of the most interesting features to study in the movement of the human body. The most appropriate technique for capturing gestures is the sketch, using pencil, charcoal, or pastel. Capturing a particular gesture is not easy; on the contrary, it requires patience, a good power of observation, and, above all, a great capacity for synthesis.

Figures and Sketches

Sketching movements is one of the most complex tasks for an artist. The figure should not appear static, and for this reason, mannequins are useless since they cannot move. The aim is not only to capture the anatomical reality of a figure in movement; the strength and kinetic qualities of the figure should also be felt, as in a snapshot taken at low speed. A sketch is always based on the relationship between the different parts of the body and its axes, which are the spinal column and the shoulder and hip lines. These three axes are essential in understanding how to represent movement.

Blocking In a Sketch

To block in a sketch correctly, it is necessary to establish a simple, quick construction with the least modeling possible. The pencil or charcoal should not be held at a right angle in relation to the paper, since this position makes it difficult to control the pressure applied, and results in neither firm nor thick lines. A slightly inclined position is easier to control, enabling you to vary the thickness of the line with the angle of the drawing tool.

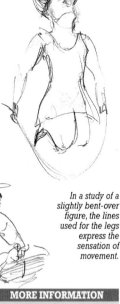

In a study of a slightly bent-over figure, the lines used for the legs express the sensation of movement.

Sometimes the blocking in is achieved immediately, capturing the movement at the first try. At other times, the sketch may require several quick stages, starting from a simple construction and gradually reinforcing it with more complex forms.

Lines and Movement

The type of lines used for sketching movement or gestures is quite different from that used for figure studies. Movement requires a great capacity of synthesis, the ability to capture with a single stroke the gesture one is trying to represent, so the strokes will not be as clean as those used for studies of anatomy or proportion. The lines representing the structure of the figure should be denser, and the lines used for large and dark shaded areas should be thicker. The main forms do, however, require more carefully applied lines to reinforce the sketch.

The gesture is expressed in the main lines of the figure.

MORE INFORMATION
• The parts of the body and the sketch, **p. 16**
• The model outdoors, **p. 56**
• The figure in motion, **p. 64**

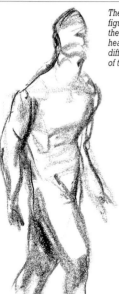

The movement of this figure is indicated by the legs and the raised head. The lines are different in each area of the sketch.

A flat stroke for blocking in the form.

The main features.

Reinforcement of the lines.

Blocking in the bone structure.

Sketching and Modeling

When sketching a figure in movement, techniques such as the gradation of tones and the detailed drawing of the forms should be avoided, simplifying the figure as much as possible. The gradation of tones should take the form of simple shading, done with either a pastel held flat or in pencil, shading in a gray area without going into detail. When the shading is done in graphite pastel or charcoal, some tonal values can be added, darkening the area simply by increasing the pressure of the drawing tool on the paper.

Graphite allows you to adjust the tone with a simple change in pressure.

Gestures and Distortion

The representation of movement in the human figure can take two basic forms. One is to see a frozen figure captured as a quiet image. This can be done using photographs or even an articulated mannequin as the model. The other is a more direct process that implies extra effort on the part of the artist: the application of kinetic movement in the drawing or the painting. This kinetic movement is implied by a distortion of the drawn figure in the direction of the movement the artist wishes to achieve. It is best to do a preliminary study of the direction of the movement.

These two figures have a certain rhythm in the stroke, yet they are not fully defined, and the hands of the figure on the right have been exaggerated.

Artistic Perfection in Movement

Fuseli's work is characterized by his great mastery of drawing, allowing him to capture the movement of the figure with great spontaneity. The synthesis of the forms of the figure is based on the rapid application of color, constructing planes with just a few brushstrokes and creating a sensation of movement, proportion, and synthesis.

Henry Fuseli, Satan and Death Separated by Destiny.

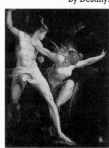

THE CLOTHED FIGURE AND ITS ANATOMY

Drawing a clothed figure is quite different from drawing a nude. Of course, it is still necessary to establish the proportions between the limbs of the figure, but the clothes not only limit our perception of these proportions but also model the form with their folds and creases. It is necessary, therefore, to study how clothes react to different poses.

Mass and Form

There are many ways to interpret the mass created by clothes on a figure. When drawing a clothed figure, the main problem is usually the mass

Clothes follow the movements of the figure. The elasticity of the fabric determines the way they cling to the body. Wrinkles and tension appear at the joints of the limbs.

Extending the arm creates creases that follow the direction of the movement.

The effect of tension between the elbow and the back.

formed by the fabric. Make sure that deep creases do not appear to go deeper than that part of the body they are covering.

Clothed figures take a series of forms that require a detailed study, particularly when the limbs are flexed or extended.

Internal Structure

The figure can be outlined with a few main lines representing the principal axes of the body—the spinal column, the shoulder line and the hip line. These lines are the basis for a sketch of the figure, starting with geometric forms that are later modified. You can then experiment with adding different types of clothes over this basic internal structure. It is important, however, to let this structure determine the form of the clothes and not the other way around, in which case the figure would seem distorted.

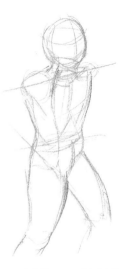

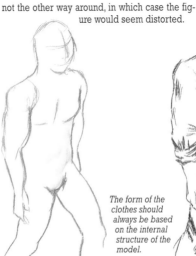

The form of the clothes should always be based on the internal structure of the model.

A Study of Fabrics and Folds

A good way to practice drawing wrinkles in cloth is to use a piece of fabric as a model. It should preferably be a white rectangle, placed as shown in the examples, and lit with artificial lighting. This type of lighting is ideal for emphasizing light and contrast.

When preparing the drawing, it is advisable to include the symmetrical axes within a box. These are the basis for the deepest wrinkles, leaving the evaluation of the shadows for the end.

Simplifying a Clothed Figure

Reducing forms to their essentials is one of the best ways to represent clothes on figures. When the fabric has many wrinkles, not all of them need be shown, as this could interfere with the internal structure of the figure. Only the main wrinkles should be indicated to avoid "overcharging" the model.

Usually when the figure is drawn from memory or invented, the artist may try to include too many forms, which only leads to a lack of credibility. On the other hand, the simpler the forms, the clearer and more credible the figure.

In this example you can see how excess detail leads to a lack of realism. Simplified forms, however, represent the clothes just as well without the figure appearing overembellished.

Preparing the model.

Sequence from a study of wrinkled cloth.

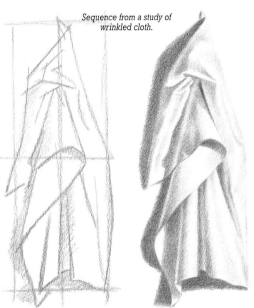

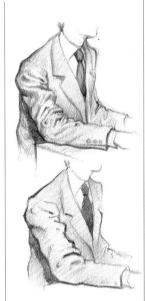

MORE INFORMATION

• The clothed figure, **p. 86**
• The clothed figure in oil, **p. 88**

THE MANNEQUIN AS A MODEL

A mannequin is always useful for capturing the different postures of the model. The simplified forms of the mannequin enable the artist to produce a simple and logical sketch for the figure. Mannequins can also be used to draw groups of figures, or to study different poses.

The Articulated Mannequin

An articulated mannequin really simplifies the task of figure drawing. These models are sold in stores that specialize in fine arts and come in all sizes, qualities, and prices, depending on the quality of the wood, the number of possible movements, and the finish of the forms. Even though they are only a guideline, some are better suited than others.

Some articulated mannequins offer a wide range of movements while others are designed for studying specific parts of the anatomy, such as the hands. This latter kind is particularly useful for studying the different positions the hands can take, as hands are the most complex part of the human figure.

Articulated mannequin.

Making a Cardboard Mannequin

There is a quick solution to sketching from a mannequin—making your own from cardboard and wire. It is not difficult; you only need a little skill and the patterns given on this page. They can be copied onto a piece of paper or else photocopied and enlarged. Then the paper is pasted on a piece of cardboard, cut out, and mount-

Plasticine Mannequins

Different kinds of mannequins can be used as models for drawing poses which would be difficult to reconstruct from memory. Sometimes none may be available, but you can always build an emergency mannequin with plasticine. It will be a rough model, but capable of adopting any position imaginable.

ed on a skeleton made with wire, as shown in the example. This kind of mannequin is not as flexible or as sturdy as the wooden type, but although it has limitations, it provides a three-dimensional model, which is the main purpose of a mannequin.

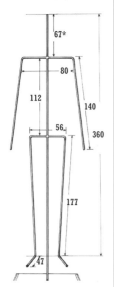

67*
80
112
140
56
360
177
47

Wire skeleton, in proportion, measured in millimeters.

Pattern for making a cardboard mannequin.

Mounting the figure onto the wire with cellophane tape.

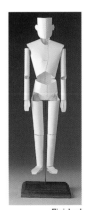

Finished mannequin.

The Figure and the Pose

The mannequin is made of very schematized forms and geometric volumes. For this reason, it gives a very good idea of the volumes that should appear in the painting.

A mannequin can take any possible pose; twists and turns, movement, and even the foreshortening of various positions can in this way be studied by the artist. Mannequins also offer a variety of linear sketchs that can be used in conjunction with studies made from a live model, giving the artist an understanding of the most complex lines.

An Aid to Drawing

An articulated mannequin is one of the most useful aids available for studying figure poses, but it can never be more than that. It helps in studying the pose, yet real models provide reference points that wooden models lack, such as different flesh tones and, of course, a more realistic build.

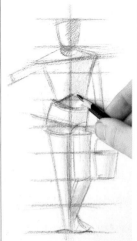

Constructing the forms over the sketch.

In the finished drawing, shading and modeling the forms helps to complete the representation.

One of the advantages of the articulated model is that it can be "frozen"—that is, placed in a static position in the middle of a movement, such as running, jumping, or twisting at the hips. Such poses would be impossible for a real model to hold.

The Reference Point

The mannequin is, in a sense, a sketch of reality, a practical model that can be used for complex poses or simply to replace a real model when none is available. It should, nevertheless, be treated only as a reference point used to direct the artist's attention during sketching sessions. Alternating between the mannequin and a real model enables the artist to form a more objective view of how to simplify the forms.

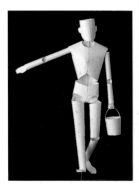

MORE INFORMATION
• Poses: *contrapposto*, **p. 10**
• Obtaining the proportions of the figure, **p. 14**
• Live and artificial models, **p. 18**

The mannequin should be placed in a position that appears in motion.

Applying the standard to the sketch.

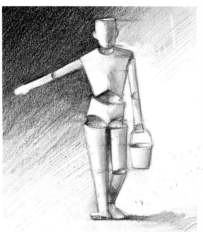

THE MODEL OUTDOORS

The figure should not be depicted only in the studio. The street offers many opportunities to draw different people passing by. The most likely places are those where people are waiting, strolling, or resting. They must be captured quickly and concisely, which is a fine exercise in synthesis and agility.

A Sketchpad for Quick Sketches

Working outdoors offers a wide range of figures and compositions. It is as if the artist had an infinite source of images to use as his models.

The most practical media for sketching people in the street or in a park are graphite, pencil, or pastel, which are suitable for quick, direct sketches. Pastels may be used if color is wanted. A small sketchpad is the best support for quick sketches. It should not be too large; the ideal size is one that fits in the artist's hand.

Charcoal and Pastel

Although both charcoal and pastel are quite unstable to the touch, they are fully compatible when used together and excellent for quick, spontaneous work, capturing the model almost instantly.

First, you must define the space that the model will occupy within the picture—that is, establish its proportions in relation to the frame. Once this point has been decided, the mass of the figure is drawn with the charcoal held flat against the page. Horizontal lines are used for shading in planes of gray, and vertical ones for blocking in lines. To soften the shading, lightly brush the paper with a piece of cloth or blow on it to remove some of the charcoal. Pastels are then used to add color and strengthen the forms of the figure. The finished drawing should be protected with pelure paper.

Pastels and charcoal are good for quick sketches.

A wide variety of images can be found. Any everyday situation can be a good starting point for the development of a figure.

Observation and Synthesis

A study of a person who is not posing needs to be done as quickly as possible. To do so, the artist needs the ability to synthesize and to be able to

Sketchpads in any format are the most useful material for sketches.

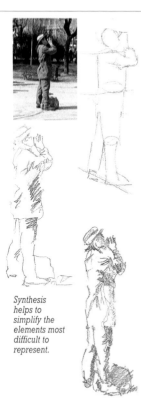

Synthesis helps to simplify the elements most difficult to represent.

remember the proportions and the pose. But there are techniques that enable the artist to sketch a model quickly. When drawing with a graphite stick, hold it flat and shade in the volume of the body after having previously positioned the hip and shoulder lines. Then add the arms and legs to the torso, along with the ground on which the figure stands.

Choosing the Model

A person in movement is always more difficult to represent than a model standing within a confined space.

To paint or draw people walking, work from a distance that allows you to follow their entire movement comfortably. A street scene also offers other simpler possibilities, such as people waiting in line for a bus.

In a park, it could be a man reading or a woman walking with her child. These models are often static and provide a good opportunity to make a quick sketch.

You can also sketch a person sitting in a bar, even though they may realize they are being drawn.

Studio Work

Once you have a good selection of sketches, these can be completed in the studio to serve as the basis for developing a picture. The material gathered in a sketchbook can be used on many occasions, as the model need not necessarily be in the place the artist has chosen to represent in his work.

A sketch made spontaneously, in the street, always provides a good motif for a picture.

The Characters of Ramón Casas

This great Catalan artist made numerous sketches in charcoal of different characters, though the most outstanding represent personalities of the cultural circle in which he lived: painters, comedians, actors. Most of these drawings were made in bars or in the street.

Portrait of Picasso. Casas portrayed all the modern figures of his time.

MORE INFORMATION
• Poses and models, **p. 58**
• The figure in motion, **p. 64**

POSES AND MODELS

The best way to master poses and movement is to draw figures from nature. The figure is represented in two basic forms: clothed or nude. Either choice is important for carrying out an in-depth study of the model, both in terms of anatomy and the different postures the human body can adopt. Only with exhaustive drawing practice can the artist acquire a sound understanding of the human figure.

Pose and Composition

One of the most important elements in a composition that deals with the figure is the choice of the pose. When the model takes a pose, a series of lines and forms are produced, providing the main compositional elements of the figure. Once it has been blocked in, therefore, the composition is determined by the positions of the different masses that make up the figure. A figure curled up on the floor makes for a circular composition, while a figure seated on the floor leaning on one arm produces a triangular composition.

Elements to Bear in Mind for a Pose

The pose is the basis of any study of the figure independent of the medium used. All possible compositions, blocking in, and technical applications, therefore, stem from the pose. To achieve a coherent work, some practical considerations should be taken into account. The pose must fit within a format in which the model's masses as well as the surrounding space are distributed appropriately. When working in the studio, you should draw studies of your model in various poses, but don't attempt anything too complex; simple poses are best, since they allow you to obtain a correct balance of the

Appropriate lighting and a correct distance between artist and model are essential for understanding the pose.

masses and prevent the model from appearing too constrained. The model should be placed far enough from the painter so that he or she can see it perfectly without having to lean back.

Chance Models

The artist is not limited to drawing models in the studio. Other good places for studying poses include the street, the home, a bar. This type of exercise allows you to improve your fast-drawing skills.

Another type of pose is the "immediate" pose—capturing a model in the moment of performing a specific action or resting. These types of studies provide useful anatomical information about the relationship between the different parts of the body.

No material preparations are necessary for this type of work, since the free nature of these sketches allows them to be

From the beginning, the pose must be understood as a simple geometric form, which is then framed within the chosen composition.

executed with any basic drawing or painting implement, such as a pencil or pen, etc.

A café is a good place for drawing or painting fast sketches.

The Pose and Rhythm of the Lines

The structure of the forms within the composition is determined by a series of internal lines. This structural construction of the work should be carried out in two phases: the first one consists of establishing the general composition of the work on the basis of its predominating lines; the second defines the model's internal lines, or the composition of the figures if there are more than one, within the overall picture. The pose of the figure usually possesses a rhythm that has to be transposed to the picture through the different lines of the composition.

MORE INFORMATION

• Obtaining the proportions of the figure, **p. 14.**
• The model outdoors, **p. 56**

Making Quick Sketches in the Street

As we mentioned earlier, the street is an ideal place for making quick sketches. You need only a pencil or charcoal and a small drawing pad. The best way to make sketches is to make yourself relatively inconspicuous. First, a general view helps to center the figures that could serve as models; then a series of sketches are made to block out the subject's shape and features, without attempting any details. Finally, emphasize the flexed joints and make sure of the proportions of the body.

In order to understand the model's shape it is essential to get it down on paper as quickly as possible.

Immediately afterward, open up the bright areas with a rubber eraser and extend gray over the entire figure.

Correct the grays with a rubber eraser and add more details to indicate the surroundings in which the figure is positioned.

Spontaneity Captured by Toulouse-Lautrec

Toulouse-Lautrec (1864–1901) was not only an exceptional draftsman, his visual memory allowed him to capture figures in the most natural poses, almost as in a photograph. In his favorite haunts, the master drew numerous drawings and sketches of his circle of friends.

Toulouse-Lautrec had such a mastery of drawing that he was able to capture, in a matter of seconds, poses as complex as the one in his Rider on a Galloping Horse.

Add the dark zones without actually modeling the figure.

TECHNIQUE AND PRACTICE

TECHNIQUES: SKETCHES IN CHARCOAL

Using charcoal to represent the human figure allows us to make corrections as we draw. With charcoal, it is possible to draw the basic shape of the model, correct or improve it, model it, etc. Therefore, charcoal is an ideal drawing medium for making an in-depth study of the human figure.

An Approximation of Forms

Unless it is fixed with a special spray, charcoal is an unstable medium. It is precisely this characteristic that makes charcoal so appropriate for drawing studies of the figure, since errors and uninteresting lines can be removed simply by blowing the charcoal off or wiping it with a cloth.

The forms should first be sketched using the flat side of the stick in order to precisely define the general shape of the model.

The first shapes are sketched with the flat side of the stick in order to block in the figure within basic geometric forms.

The Possibilities of the Medium

Charcoal is an ideal medium for drawing lines or modeling a figure. The possibilities it offers lie in the fact that any area can be corrected while it is being drawn. The charcoal stick can be applied in three basic ways:

Since charcoal is easy to manipulate, you can smudge it with your fingers. This technique is ideal for creating planes of shadow.

using it like a pencil, a technique allowing the addition of details once the general shape of the figure has been drawn; rubbing the piece from side to side in order to obtain broad tonal areas; and applying the stick lightly on its flat side in a downward movement to draw straight lines.

Immediate Corrections

One of the most versatile characteristics of charcoal is that it can be erased easily whenever an error has been made. To correct an area of the drawing, simply rub a cloth against the paper and draw the erased section over again. It is not necessary to use an eraser unless you wish to create highlights over areas already colored in gray. In this case, you will need a kneaded eraser, which is soft and can be cut into small pieces and molded into a tip.

MORE INFORMATION

- Relationship between the background and the figure, **p. 32**
- Gestures, **p. 50**
- Techniques: pastels and chalk, **p. 80**

A cloth is indispensable for subtly smudging or for opening up whites.

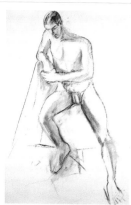

The drawing is perfectly established, the areas of light and shadow have been defined by means of superimposed planes.

A Learning Medium

There is no better medium for learning how to draw the human figure than charcoal. Both in the construction and the modeling of a drawing, charcoal enables the artist to compare the earlier stages with what he is currently working on. That is to say, starting from an almost linear sketch, the artist can continuously compare his current result with the lines he has previously drawn, and eventually merge them through blending, or simply erase them.

The tone of the gray areas has been enhanced, modeling and rounding off the forms.

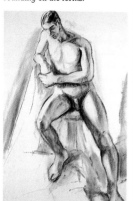

A kneaded eraser is used to open up white and bright areas.

The proportions and the relationship between gradated zones have been drawn with care.

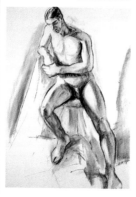

Charcoal is ideal for drawing the preparatory sketch of a picture to be executed in any pictorial medium.

Fixing Charcoal and Detailing the Figure

It is advisable to use fixative to preserve each stage of your drawing in its definitive form. Once the fixative is dry, you can work over the fixed area without fear of accidentally disturbing it while working on it or erasing a newer addition.

The Foundation of Any Painting

Thanks to its flexible nature, charcoal provides an excellent base for a painting in any pictorial medium and is compatible with all of them.

Charcoal can be used to include as much definition and detail as the medium in question requires. The basic drawing for an oil painting can be either very detailed or merely sketched, since the construction can be carried out with paint; on the other hand, when using watercolor, the drawing must be as detailed as possible, although it should not contain any dense shaded areas. It is essential to remove the charcoal dust before beginning the painting.

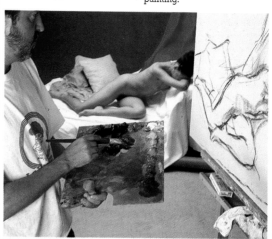

TECHNIQUES: BLOCKING IN GEOMETRIC FORMS

The system used to construct a figure is mainly based on understanding it in a simplified form. One way of drawing forms, therefore, is to summarize them in simple geometric shapes. Everything in nature can be reduced to geometric forms; even the most complex subjects can be understood as an ensemble of simpler geometric shapes.

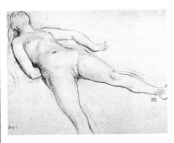

No matter how complex a form appears, it is always best to reduce it to a simple geometric form, as illustrated in this example by Degas.

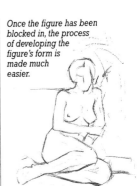

Once the figure has been blocked in, the process of developing the figure's form is made much easier.

From the Model to the Synthesized Form

When observing a model and before drawing it, the artist must always be aware of the placement of the model in the surrounding space. The model's forms can be summarized within a four-sided polygon, a rectangle, a trapezoid, a diamond shape, and so on. It is much easier to understand the distances between the different parts of the figure when it is blocked within one of these shapes. Furthermore, this technique is also useful if the forms need to be further reduced to specific geometric forms.

All bodies can be blocked in correctly by reducing them to simple forms.

it in always becomes more complex and less precise.

To reduce a model correctly on paper, the painter has to see the figure as an unrecognizable and abstract object made of a few main lines of reference. For instance, when drawing a seated figure seen from the front, it is best to understand it as a rectangle; if, on the other hand, you are trying to represent a torso with folded arms, its form could summarized in a triangle.

Reducing Bodies

In drawing, all the elements of nature can be reduced to two-dimensional shapes (those represented in the painting or on paper) that are much simpler than their real ones. This process provides a simplified model, without which blocking

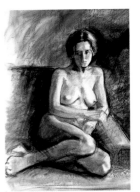

Fast Blocking In

Blocking in can also be carried out quickly, without resorting to geometry, by using the framework of the painting to understand the space surrounding the figure. This will allow us to take down reference points that will come in extremely useful when establishing the figure's measurements. In fact, blocking in a figure should always be executed

Blocking In and the Internal Structure

The model's internal structure can always be reduced to basic geometric forms that best fit the composition of the picture. Even the great masters began their work in this fashion. Leonardo da Vinci's works were laid out with an almost mathematical precision, in which the forms were never fortuitous but resulted from a careful study.

A balance between the internal and surrounding space of the figure gives an understanding of internal and external volumes.

These two illustrations show the relationship of the figure to the surrounding space.

rapidly; on the other hand, the artist should refrain from attempting a detailed representation with this method, since it complicates the process considerably. The figure must first be defined generally after which the details and features can be added.

Division of Complex Elements

Human figures present complex forms, either because of the angle from which they are observed or because of their foreshortening and pose. Certain difficulties arise when blocking them in; but if this is done in parts within the general sketch, the composition will be much easier to establish.

No matter how complex the figure is, you should always begin by drawing a rough sketch; that is, treat the figure

The shapes of this figure are potentially complex. But they can easily be drawn by first blocking in the figure as a whole and by blocking in each of the figure's smaller and more basic forms afterward.

as a large mass. Once the initial sketch is finished, the internal volumes of the masses and limbs can be added by blocking them in individually, always keeping in mind the proportions between the different parts of the body. This process is achieved by transferring the figure's measurements to the canvas.

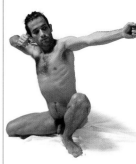

To draw the model, the artist first defines the general form and then adds the details within the outline that contains them.

Approximation to the Model

A good schematic drawing of the general lines of the model provides a stable base on which a drawing or a painting can be executed.

MORE INFORMATION
• The parts of the body and the sketch, **p. 16**
• The figure as a method of study, **p. 28**

THE FIGURE IN MOTION

One of the most interesting exercises is to draw sketches of figures in motion.
For this purpose, the artist needs to work with media that will allow him to draw rapidly and to
make corrections during the execution, such as charcoal, chalks, pastel, and even watercolor.

The Quick Sketch

Motion is difficult to capture; however, this task can be made easier if the figure in motion is drawn within a basic sketch. The sketch of a figure in action should be established from the relationship between the spine and the limbs, which are carrying out the movement. The trunk is drawn quickly as a single thick, directional line using a flat stick of charcoal or graphite. Then a second stroke is extended from it to represent the line of the leg in motion. Then the leg supporting the weight of the body and, finally, the arms are added.

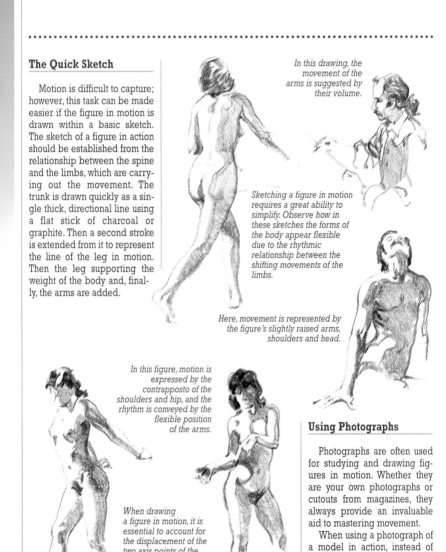

In this drawing, the movement of the arms is suggested by their volume.

Sketching a figure in motion requires a great ability to simplify. Observe how in these sketches the forms of the body appear flexible due to the rhythmic relationship between the shifting movements of the limbs.

Here, movement is represented by the figure's slightly raised arms, shoulders and head.

In this figure, motion is expressed by the contrapposto of the shoulders and hip, and the rhythm is conveyed by the flexible position of the arms.

When drawing a figure in motion, it is essential to account for the displacement of the two axis points of the body. Note in this example, for instance, how the weight falls on the foot placed in front while the force produced by the arms drives the trunk forward.

Using Photographs

Photographs are often used for studying and drawing figures in motion. Whether they are your own photographs or cutouts from magazines, they always provide an invaluable aid to mastering movement.

When using a photograph of a model in action, instead of trying to make a faithful copy of the figure itself, the artist should consider only those parts he wishes to represent in the painting.

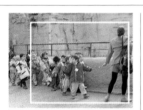

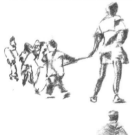

Motion and Duchamp

In 1912 Marcel Duchamp (1887–1968) exhibited his work, *Nude Descending a Staircase,* in New York. This picture represents the first attempt at depicting photographic movement in a style close to Cubism. It shows a male figure in motion, capturing in one single plane the entire sequence of the motion.

Duchamp, Nude Descending a Staircase.

After selecting the composition, the model's basic forms must be taken down on paper as quickly as possible, capturing the gesture and leaving out unnecessary details.

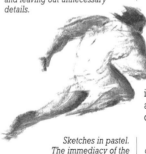

Sketches in pastel. The immediacy of the moment has been captured with only two colors.

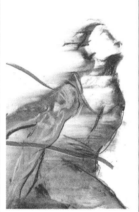

A Sketch in Pastel

When representing a figure in motion, it is always best to start from an original referent, even when you are working from a photograph. A sketch is necessary to capture a moving figure; once it is drawn, you can then add some color and blend it into the background. Pastel is the most direct medium of all, therefore it is ideal for working over an initial sketch. First the figure's basic structure is drawn with the pastel using pencil-type lines, then finally the color can be further developed.

The Process of Detailing a Painting

With a preliminary sketch in monochrome or color, the artist can then integrate the figure into the composition. Since a solid graphic base has been laid, the figure can be drawn using the same technique as in the initial sketch, but with the added possibility of making corrections.

This sketch in pastel was used to develop a more detailed work. The anatomical study was the base for constructing the pose.

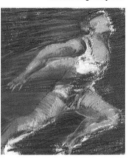

Simplification of Form

The human figure in motion has to be captured in a purely simplistic way, without including any details of the model. When the subject is performing a fast action, it is essential to use as few forms as possible in order to produce the desired effect. The faster the movement, the greater the simplification required. Furthermore, the distance between the figure and the beholder, or the artist representing it, also influences the result; a figure walking in the foreground is seen in more detail than one occupying a more distant plane.

MORE INFORMATION
• Gestures, **p. 50**
• The model outdoors, **p. 56**

TECHNIQUE AND PRACTICE

THE FIGURE IN PAINTING AND DRAWING

The way the figure is integrated into the picture depends on the artist's intention and pictorial style. In any case, it is always interesting to observe the transformation of the figure in a given pictorial style.
Independent of the style or medium chosen to execute the work, all paintings must begin with a drawing.

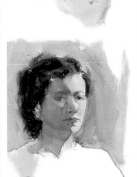

In this figure, the forms are represented by color defining zones of light and shadow without including any excessive intermediate tones.

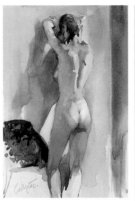

This figure seen from the back was painted in watercolor. The construction of the forms is based on a tonal gradation, starting from lighter tones to the darker ones.

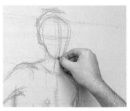

Beginning an anatomical study.

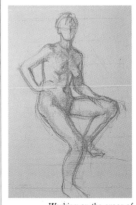

Working on the areas of light and shadow.

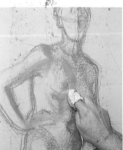

Blending tones and modeling shadows.

In this watercolor portrait, the distribution of light and shadow perfectly expresses the model's features.

The Direct Style

The technique of direct painting is one of the most difficult ways to represent a figure, since it entails skipping all intermediate steps designed to integrate the forms of the model into the picture. This technique requires a comprehensive knowledge of human anatomy and good drawing skills. In direct painting, the color is applied from the outset, defining the color and definitive forms of the work.

The Study

The study allows the artist to make a detailed analysis of his subject. With it, he can calculate the figure's proportions, study different poses, and model the forms.

Only an in-depth study can enable the artist to represent the figure from any viewpoint. Of course, calculating the measurements and proportions of the figure is essential for producing an anatomically correct representation.

Working in Stages with Pastel

When the study ceases to be a mere drawing and starts to include color, two different phases must be respected: During the first one, a monochrome drawing is completed; during the second one, modeling is added with color. As always, a study of the figure's anatomy and pose must be drawn, preferably in a flesh tone. To the values indicated in this version, we can add brighter colors and darker shaded areas. It is not advisable to mix different pastel colors, therefore the necessary intermediate tones must be readily available.

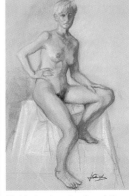

Sketch showing a tonal gradation in color on tinted paper.

MORE INFORMATION

- Obtaining the proportions of the figure, **p. 14**
- The figure as a method of study, **p. 28**

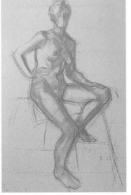

Blocking in and gradation with a single tone.

After adding the bright tones, contrast is created by means of darker ones.

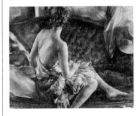

Over a perfectly finished and fixed drawing, different tonalities are applied following the original tonal gradation. This process allows us to preserve the shadows.

Synthesis and Development

To achieve a fully developed work, it is necessary to start from a general outline in order to draw the forms without overburdening them with details. A high-quality and detailed painting undergoes several elemental phases: a detailed study, a monochromatic tonal gradation, and, finally, the modeling of the forms with color.

Blocking in is used to define the tonal gradation of all the figure's volumes.

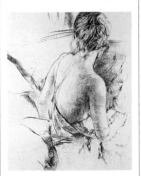

Tones are alternated with points of maximum brightness, added as contrast to the darker zones.

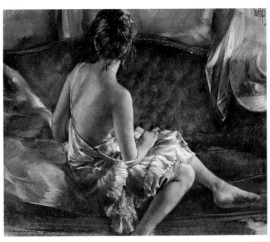

LIGHT AND SHADOW IN THE FIGURE

Chiaroscuro is used in painting as a method for modeling the forms of figures through contrasts of light and shadow. It is particularly appropriate when the light is strong or the model is in an interior setting. The chiaroscuro technique defines the areas of light by using light tones that create a sharp contrast with the areas remaining in the shadow.

The light from the window falls only partly on the model. The other areas of the figure tend to blend with the background tones.

The structure of the figure in this painting was drawn directly with a brush.

The Model and the Sketch

Chiaroscuro consists of modeling the figure's forms from the point of view of light and shadow.

The model painted in chiaroscuro should relate equally to both the areas of light and the darkest shadows. A model can be seen in chiaroscuro when the light strikes it directly in such a way that the shadows of the hidden parts become the same color as the dark background. The lighting can be natural (a window) or artificial (a lamp).

The sketch should be drawn on colored paper, allowing the artist to add brighter colors to make a better in-depth study of the light.

The palette in this example includes gray, burnt umber, permanent red, vermilion, medium cadmium yellow, and white.

Blocking In the Shadows in the Painting

Your choice of palette should be established from the outset. In general, a painting in chiaroscuro requires tonal variations within a limited range of colors. However, the palette includes the darkest and brightest colors.

The first step is to define the tones corresponding to the shadows; this can be done directly with a brush, marking out the parts of the figure that are in shadow.

The success of chiaroscuro is based on a correct initial construction of the figure, since, as the work develops, some tones may appear identical, thus creating some confusion between the different forms.

From the very outset, color is used to sketch and to create the first contrasts.

Adding Color to Chiaroscuro

When the artist adds color to a work in chiaroscuro, he must respect the direction of the light falling on the model's forms; this explains why the tonality of light and shadow must maintain a relationship within the color scheme of the work; this means

The Figure in Painting and Drawing
Light and Shadow in the Figure
Acrylic: Flat Colors and Color Masses

69

The brightest tones in the figure are the highlights.

A Series of Planes in Chiaroscuro

The figure painted in chiaroscuro relates directly to the various planes of the picture, fading into areas of shadow and standing out when hit by a ray of light; this formula was used by Rembrandt in most of his work.

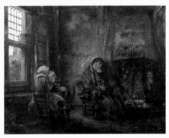

Rembrandt, Tobias and Ana Waiting.

that, although it is possible to introduce medium tones taken from the entire chromatic scale, the most important tones should resemble each other. In the areas of maximum light of these tonalities, bright colors can be included that only vary in warmth with respect to those located in bright areas of different chromatic ranges.

Since the painter began with a colored background, adding chromatic layers allows the base color to come through the recently painted areas, thus blending the color of the background with the whole.

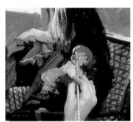

Highlights and Contrast

The construction of forms based on color in a chiaroscuro painting is completed only when the highlights defining the limits between the forms are added.

The brightest areas are characterized by a rigorous model-

The tones used to make highlights model the forms and separate the different planes.

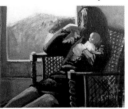

ing of the forms, observing which are the brightest areas of the model and the texture of the surface from which they are reflected. The highlight on a rounded form like the head will be different from that of the leg.

MORE INFORMATION

- The relationship between the background and the figure, **p. 32**
- Two styles of painting, **p. 34**
- Tonal gradation and use of color in the figure, **p. 84**

The Medium and Chiaroscuro

Each pictorial medium has its own techniques for adding highlights and bright areas. Opaque media make it possible to paint light colors over dark ones, thus allowing the painter to start working from the figure's darkest areas and subsequently adding highlights to bring out the forms. With transparent media like watercolor, however, it is necessary to reserve the light areas from the outset, proceeding from lighter to darker tones.

Specific highlights define the most important points of a finished form; the light falling directly upon these points creates highlights which are almost completely white.

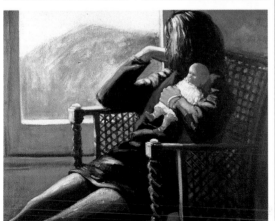

ACRYLIC: FLAT COLOR AND COLOR MASSES

The painted figure can be understood in a variety of ways. From a chromatic point of view, however, its forms can be defined in two different ways: through planes of color or tonal gradations.
Acrylic paint offers several advantages over other wet media used to paint color planes: It dries quickly and is opaque. These characteristics allow for the superimposition of planes in the form of strokes, washes, or simple color masses.

Acrylic, a fast-drying medium, is soluble in water and allows for subsequent additions of oil paint.

Blocking In Using Acrylic

Acrylic paint is made up of resinous particles in suspension. This gives it a shiny texture which, after it has dried, becomes transparent and stable. Adding pigment to this medium produces one of the most polyvalent pictorial media available today. Acrylic can be used to apply transparent and opaque layers and allows the artist to correct at will and include details.
The blocking in of a figure that will be executed in color planes can be carried out with any drawing implement, such as charcoal. Only areas that will be filled with color should be drawn.

Pure Form and Color

The first strokes are applied rapidly, without fear of applying too much. Since we are working with an opaque medium, any error can be easily and quickly painted over.
English red applied over the ochre background help to emphasize one of the most

The first sweeping strokes are applied to obtain the correct tones and colors.

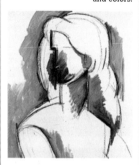

Because acrylic dries quickly, it is possible to touch up tones and colors in a very short time.

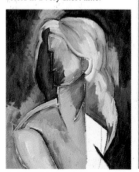

important elements in the composition: the dark background allows the central motif to be highlighted. Painting the hair the same color, however, establishes a perfect relationship between the background and the figure.

Superimposing and Cleaning Planes

Some areas, initially used to establish a coherent chromatic range, may need to be corrected, such as the lower part of the face. Using an extremely light ochre tone, the nose is outlined, and the darkened area of the chin is corrected. White, slightly grayish, is also applied to the areas that will serve as a background for new coats of color. The planes or masses of color are gradually refined,

Once the appropriate tones have been found, the artist starts to work on the less defined areas by painting over them with large masses of color.

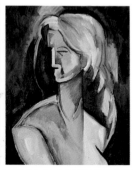

eliminating areas that are confusing or grayish.

Acrylic paint dries fast—just a few minutes with good ventilation, during which time you can reflect on the color used. In this instance, the artist decided to paint the hair a more uniform color, applying tones of English red over almost its entire surface; the background, in turn, had to be darkened until it is almost black.

Conclusion and Finish Through Color Masses

The definitive color range of a painting can drastically change the color of the planes that make up the figure. The painting becomes almost monochrome, with the predominance of greenish ochre shadows. Once the forms of the different color masses have been definitely established, a final layer is applied to give them a clean and concise appearance. Finally, the details are added, such as the orange tones on the upper eyelid, the triangular outline of the eye, and the reflections in the hair.

Other Plastic Possibilities

The acrylic medium allows the artist to apply paint in flat planes, with possibilities as wide-ranging as oil paint. Acrylic can be used to paint with a range of original values, modeling forms with tonal gradation, applying glazes, painting with different materials in the paint, such as ground marble and sand, to obtain texture.

MORE INFORMATION
• Two styles of painting, **p. 34**
• Painting and synthesis, **p. 92**

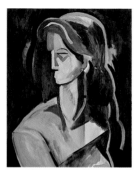

Successive layers of color create volume through planes; such Cubist connotations are easily expressed due to the fast-drying nature of acrylic.

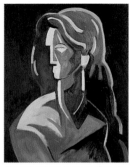

The colors have been purified, the ochres have been made warmer, and some areas, such as the eye and the lips, have been outlined.

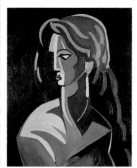

The final color of the background is established and darkened, while some grayish planes have been cleaned up. The color range uses neutral tones tending toward green.

Latex and Acrylic are Not the Same

Many nonprofessionals are unable to understand the difference between latex and acrylic. These two resins have completely different origins: latex comes from plants, while acrylic is a polymer. The former tends to dull color and reduce the intensity of its shine; acrylic resin, on the other hand, when properly mixed maintains the integrity of the color once it has dried. One final consideration: Latex paint lacks volume, while acrylic can reproduce the texture of the brush it has been applied with.

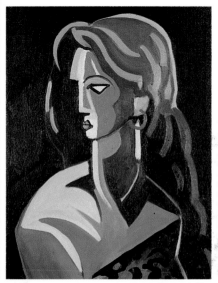

The final touch consists of outlining the masses of color that appear doubtful. Some ornamental details, such as the strokes in the lower half of the figure or the red earring, have been corrected.

TECHNIQUE AND PRACTICE

SHADING IN PENCIL

Modeling volume with a pencil leads to a perfect definition of form. However, there is no single technique for doing this. The choice of the method will be determined by the hardness of the pencil as well as the type of work being executed. Shading can take the form of individual superimposed strokes or be achieved through gradation and blending—very different techniques but basically the same result.

There is a wide range of pencils, erasers, charcoal, and stumps to choose from.

Tools and Materials

Since drawing is essential for representing figures, the artist must become familiar with the different implements that make it possible. Shading in pencil allows volume to be added to the figure. However, the result achieved with this technique depends to a great extent on the pencil we are using. Pencils can vary in their

MORE INFORMATION
• The figure in painting and drawing, **p. 66**

degree of hardness: the softest ones produce the blackest lines while the hardest ones draw sharp, fine lines. You will also require other tools for shading, such as erasers, cloth (when you are drawing with charcoal), and a stump—a stick made from compressed paper, an extremely useful instrument for gradating and modeling forms.

Basic Strokes and Blending

Shadows are depicted through a variety of strokes. Pencil work is based on the hatching and crosshatching of lines that gradually darken the tone as they get denser.

Each type of pencil produces a different tone of gray: Hard pencils—which are identified by the letter H next to the number—produce a softer, cleaner line, good for applying light grays. Softer pencils, indicated by the letter B, are ideal for dark shadows and should be used according to their grade: a 2B pencil, for instance, produces a softer black than a 6B.

The stump is used to blend lines together into a continuous gradation. It is best to stump with softer pencils, since the harder ones produce a more defined type of stroke.

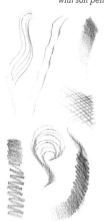

Lines and strokes applied with soft pencils.

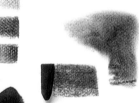

Blending with three different drawing implements: a 2B pencil, a stump, and a water-soluble graphite pencil.

Modeling Shadows

Shadows made of hatched lines can be drawn in soft pencil, provided that the volume is first indicated with a hard pencil, such as a 3H. Bear in mind that some areas of the picture will have to be left in white; these areas correspond to the points of maximum brightness. The strokes model the figure's body by rounding the form. Over the first areas of gray, darker shadows must be indicated in soft pencil, which will not be used to draw the final darker shadows. The artist must concentrate on bringing out the model's forms and increasing the intensity of the pencil work in the areas of greatest darkness.

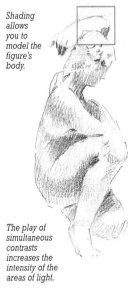

Shading allows you to model the figure's body.

The play of simultaneous contrasts increases the intensity of the areas of light.

Shadows in the Quick Sketch

The shadows in a quick sketch need not be as elaborate as in a gradated drawing. But they should be sufficiently explicit in the most important areas, depending on their brightness.

Fast sketching allows the shadows to be represented in studies.

Gradation of a scale of grays, using a soft pencil (6B) and a hard one (2B).

Shading should always be carried out in a simplified form, with a type of stroke that allows for a rapid and concise execution of the planes. The darkest areas should be tackled first with zigzag shading, with lines closer together where the shadow is darkest.

Shading by gradation is accomplished by blending the different tones of gray with a stump or fingers. The highlights and bright areas are opened up with an eraser.

Gradation and Strokes

A figure drawing frequently requires an in-depth study of the gradation of shadows and strokes. The use of different styles can bring life to the drawing and lend it dynamism, just as Ingres did with most of his own creations. The master drew his figures with fine lines, juxtaposed with in-depth, gradated studies of the areas he wished to highlight.

Jean-Auguste Dominique Ingres, Self-Portrait. This drawing has everything, except color.

Shading by Gradation

Shading by gradation is a technique in which the different tones of grays are blended together through a series of intermediary tones. To do this, it is necessary to carry out a careful study of the light and the internal structure of the figure, since the figure's forms are not established by the drawing but by light and shadow.

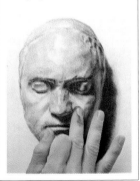

TECHNIQUES: THE FIGURE IN OIL

When oil paints from Flanders were introduced into Italy during the Gothic period, the representation of the figure changed radically. From a technical viewpoint, oil offers a wide range of possibilities compared to media such as tempera or encaustic. The color ranges and gradations available to the artist working in oil are truly rich in chromaticism and luminosity. In figure painting, such features are particularly useful for rendering flesh tones, modeling shadows, or applying glazes. Likewise, oil allows for a multitude of plastic possibilities. It can be used to create texture or a completely smooth surface.

Whether sketching a figure or applying paint on canvas, it is essential to concentrate on the proportions and composition, without attempting to include any details.

The Preparatory Drawing for an Oil Painting

The drawing of a figure to be executed in oil can be made in charcoal or pencil, or even in oil diluted in turpentine.

This drawing requires a careful observation of the model's forms and proportions, without including the details, since the dense nature of oil allows a gradual construction of the figure. The preparatory drawing must be as basic as possible, defining the figure's general forms and reducing its descriptive features as much as possible.

Painting the Figure

Once the general outline of the form to be painted is completed, the artist begins to apply paint on the canvas in order to get a general sense of the chromatic range. The different parts of the figure are painted in color area by area, without including more detail than outling them with a few strokes. The artist should remember that oil allows one to arrive at a definitive color by applying new layers of paint over the original ones. In other words, in

Blocking in the figure.

Applying the paint.

order to represent a hand, you can start from a diamond-shape painted in a flesh tone made by mixing Naples yellow and a touch of carmine; you can then paint the fingers over it with finer strokes of the same

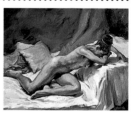

Evolution from the sketch to the final stage of a painting.

flesh tone, darkening the shadows with a touch of sienna or burnt umber and dark blue.

Alternative Techniques and Style

Each medium lends the figure its own particular qualities and characteristics. Oil allows the artist to use numerous techniques that can be easily adapted to all styles of painting. The figure can be painted from a totally figurative and realistic point of view, through a gradual construction of its forms and colors. It can then be varnished in order to reinforce its colors when the layers of paint dry. Linseed oil, turpentine, and a very small quantity of oil can be used to varnish the

Marià Fortuny, Nude on Portici Beach.

Matisse, Bather.

painting and give it a transparent coating.

The Finished Figure

Oil painting enables the artist to achieve a high degree of finish without losing the volume of the initial impasto.

The figure can be painted in a series of fine layers, done with delicate brushstrokes, which leave no tangible trace and give the canvas a smooth appearance.

The Leap to Realism

Until the Flemish painters' technique was exported to Italy in the 14th century, artists executed their works using a complex and limited medium, tempera, made with eggs or gum. Oil paint allowed for a great technical advance and painters everywhere immediately started to experiment with this versatile medium which had great possibilities for rendering flesh tones, volume, and drapery.

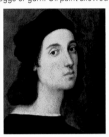

Raphael, Self Portrait. *Oil allowed for a realist representation that was impossible to achieve with tempera.*

On the other hand, the artist can apply dense layers of paint of a highly gestural nature, which will create a texture of thick brushstrokes in the paint.

Brushstrokes and Blending

The final result produced by the technique of oil painting depends on how the paint was applied from the beginning. In fact, with this medium it is possible to paint a light tone over a dark one; the painting can be touched up throughout the entire painting process. The brushstroke itself is the technique used to model the figure's forms. Therefore, it is important to bear in mind that the direction of the strokes defines the different planes of the figure. In this manner, the artist can introduce volume and blending. Blending consists of superimposing one color over another without making the underlying color completely disappear. Blending techniques are very effective when used to gradate and model forms.

| MORE INFORMATION |
| • Two styles of painting, **p. 34** |
| • The clothed figure in oil, **p. 88** |

The final stages of a painting in oil by Badia Camps.

Blending and gradating with oil paint.

Superimposing brushstrokes.

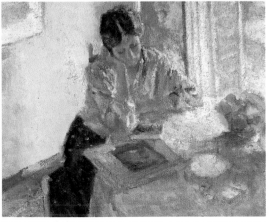

TECHNIQUES: WATERCOLOR

Watercolor is one of the most subtle and complex painting media in existence. The techniques it requires are based on the superimposition of transparent layers of color, also called glazes, to create darker tonalities. Watercolor is especially appropriate for creating luminous and transparent figures. Since watercolor cannot be corrected easily, the initial drawing should be exact.

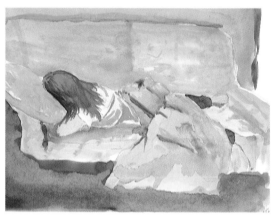

A Clear and Concise Drawing

The preparatory drawing of a watercolor should be very precise. Due to the transparent nature of watercolor, this drawing should be used as a guide, indicating where each color must be applied.

The figure executed in watercolor must include all the details of a finished drawing, with the exception of the gray areas that are left unshaded, since these areas will be graded with color.

Before starting a watercolor, the artist must make a detailed drawing without including any type of gradation.

The precision of the figure will directly affect the pictorial quality intended to be reached in the final work.

The Transparent Base

Since watercolor is a transparent medium, the artist begins the painting by applying pale, almost transparent, colors, which can then be darkened accordingly. Owing to the transparent nature of the medium, it is not possible to work from dark to light.

Starting from a completely finished drawing, the painter sets out by applying very wet colors on the brightest areas of the figure and then adds other darker colors on top. The highlights and areas of white must be reserved from the outset.

Watercolor does not include white. Therefore, white is obtained by reserving an unpainted area on the paper itself.

Two Possibilities: Wet or Dry Paint

After painting the brightest parts of the figure, successive layers of color can be applied in two different ways, depending on how you wish to treat the painting. Those parts of the figure requiring additional details must be painted only when the underlying coat has completely dried, in order to prevent the new coat from mixing with the background and blurring the details. In this manner, details can be added easily. This technique can be applied to delicate areas like the face or to

This figure was painted using both wet and dry techniques. The color blending was executed on wet paper, while the darkest tones were painted on dry paper.

A direct painting in watercolor. The dark tones were added before the base color had dried.

define separate planes of the painting, for instance, the figure's body with respect to the background.

You can also paint on a wet background in order to blend and model forms and colors without superimposing planes.

Watercolor Sketches

Watercolor is a very convenient medium for sketching figures. The artist can first paint small sketches of poses in light gouache and develop them later with a complete palette of colors.

The sketch is one of the most useful exercises for practicing

MORE INFORMATION
• The figure in painting and drawing, **p. 66**
• Figure and landscape in practice, **p. 78**

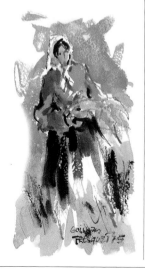

Watercolor and the Modernist Figure

Modernism adopted the themes and forms of Oriental art, in which the figure had great iconographic importance, either as the subject of a mythological theme or as a main decorative element. Watercolor was used to give color to many of those figures whose fine lines remain visible though the paint.

Anonymous, Balkis, Queen of Sheba. Oriental painting had an influence on Modernism.

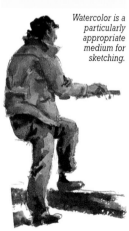

Watercolor is a particularly appropriate medium for sketching.

and understanding the figure, whether the definitive work will be executed in watercolor or any other pictorial medium.

LUCENA XX
GUILLEN
FRESQUET —

Papers and Brushes

Paper is used to paint on in watercolor. Because this medium is water-based, it is essential to know which paper to choose, since the final result will depend to a great extent on the quality of the paper.

Watercolor paper comes in three types: fine-texture, medium-texture, or rough-texture. If you want to paint a detailed figure, a fine- or medium-texture is preferable; for a less precise and more gestural result, on the other hand, a rough-texture paper is recommended.

The best type of watercolor brush is made of fine hair and possesses a suitable absorbing capacity.

TECHNIQUE AND PRACTICE

FIGURE AND LANDSCAPE IN PRACTICE

Although landscape painting is considered as an independent genre, we often see figures represented in these works. The way a figure is integrated into a landscape depends on the role it plays within the painting in general and on the level of figuration intended by the artist in his work.

The urban landscape is difficult to paint from nature, especially when you want to include people in the scene; this is why a photograph provides a good reference source.

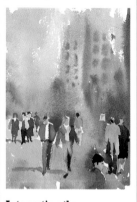

Integrating the Landscape and the Model

In most cases where a figure is represented in a landscape, a great effort of synthesis is required in order to leave out details that are not necessary to the painting as a whole. In a figure painting, the landscape is meant to create an atmosphere and not simply to fill out space. The figure should be allowed to "breathe" and its surroundings treated as a setting against which its colors and forms stand out.

Naturally, we can also paint detailed landscapes with figures, but if the figure is the main subject of the painting, it should be granted the same importance as the landscape.

The Preparatory Drawing

No matter how complex the landscape is, the preparatory drawing must emphasize the figure. Its main lines must be oriented toward the figure, relegating the landscape to a more elementary level of representation. In the case of a watercolor, the lines drawn in pencil must mark out the different areas of color within the figure. The reason is that since watercolor is a transparent medium, it requires very pre-

The main theme of this painting is a musician, his barrel organ, and a dog at rest. The composition of the figures is well balanced and the urban landscape is used as a background, giving greater emphasis to the main subject.

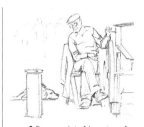

A figure painted in watercolor requires a detailed preparatory drawing, which indicates the proportions of the model as well as the zones to be painted. No shading or gradation has been added in pencil because the volumes will be suggested by color.

Adding the background, in this case the foliage of the trees, the artist has chosen a sap green mixed with a lot of water, applied with varying degrees of intensity.

cise guidelines. The area of the landscape should not be drawn, since the intention is to leave it somewhat diffuse. It will therefore be painted directly with a lot of water, leaving more water in those areas that require denser colors.

Likewise, the figures added to the background to create a sense of depth must be painted with light, direct strokes, using the white of the paper to bring out their forms.

Planes and Details

Three planes of depth must be established, each of which corresponds to a different level of representation.

The main figure is set in the foreground, where areas of different colors are indicated in pencil in the preparatory drawing. General masses of light color will be painted first, and darker tonalities added later if necessary.

In the second plane, or middle ground, we find figures that are added at the beginning.

Finally, the background is left untouched in order to create a sense of depth and atmosphere.

Depth accentuates the importance of the figure in a landscape.

Intense colors that require no modeling are used: pure cadmium red for the barrel organ, cadmium yellow-orange for the lighted area.

Burnt sienna is used for the sleeves and the neck of the shirt; the sweater is painted with a very pale sienna, with darker tones indicating the creases.

The Final Details

When all the general planes have been filled in with pale tones, the darker details and shadows can be painted, bearing in mind that the base color must be allowed to dry beforehand; if it is not, the paint will bleed into the damp areas.

The face is painted with a pale sienna wash, leaving the beard in reserve. The trousers are painted with a gray wash, lightening the brightest area with a dry brush.

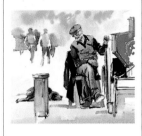

When the base color has completely dried, the folds of the trousers are painted the same color as the jacket and a dark gray tone is used to cover the leg that is in shadow.

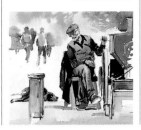

The Figurative Landscape

Many artists have painted figurative scenes set in landscapes. Traditionally, figures are only occasionally included as anecdotal references in landscape painting. Nonetheless, in some instances, such as Romantic painting, the figure is used as a point of interest in the landscape, juxtaposed against the forces of nature, as illustrated in the work of the Romantic artist Caspar David Friedrich.

Caspar David Friedrich, **Monk by the Sea**, *(detail)*.

MORE INFORMATION

• Techniques: watercolor, **p. 76**

Finally, a light gray tone is applied in the foreground and several small touches are added to define the forms.

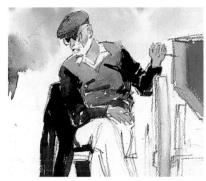

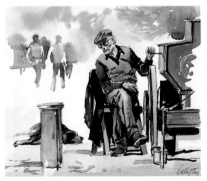

TECHNIQUES: PASTELS AND CHALK

Although pastel is considered to be a full pictorial medium, it is used and applied like a drawing medium. The directness and spontaneity of the pastel strokes can be used to produce results that look either like a painting or a drawing.
Although it is also a dry medium, chalk is better suited to drawing, since its monochrome range is an excellent way to render tonal gradations.

Technique and Form

Pastel and chalk are dry, opaque media that can be applied immediately and allow the artist to superimpose light colors over dark ones.

There are two equally valid ways of beginning a work in pastel or chalk: The artist can apply the medium like paint

Tones can be blended with a stump.

Like all dry and opaque media, light colors in pastel and chalk can be superimposed over dark ones.

The instability of pastel makes it easy to blend with a stump or fingers.

The stump is used to work more precisely on areas that are too small for the fingers.

and use sweeping strokes and broad masses to represent the basic lines of the figure, or he can make a drawing, sketching the forms and adding monochromatic tones, in the same way he would use charcoal, subsequently adding layers of color.

A Drawing and Painting Medium

Pastel can be used both for painting and drawing alike. The figure represented with pastel takes on a fresh and spontaneous appearance, provided that the colors are not blended together too much. In order to avoid this problem, pastels are available in a wide range of colors. Even if the model requires a great number of hues, the artist should avoid mixing the colors together too much, since the contact between the fingers and the alkali in the pastels produces a whitish film characteristic of a misuse of the medium.

The preliminary forms are drawn as in a gradated drawing made in charcoal.

Drawing a figure in pastel.

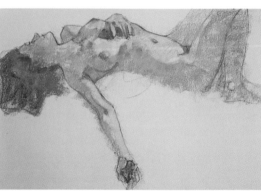

Figure and Landscape in Practice
Technique: Pastels and Chalk
The Study of One of Degas' Figures in Wax Crayon

81

The Figure and Its Gradation in Chalk

Although similar to pastel in its composition, chalk is very different in terms of its color range. In contrast to the great number of tones available in pastel, chalk offers only a very limited range of colors: white, red, and brown. Despite this limitation, there are countless possibilities for drawing figures in chalk, since these three tones can be mixed and super-imposed on each other. In addition, the artist can inte-grate the color of the paper itself into the work.

A figure in chalk must begin with a sketch indicating the proportions and forms of the pose. A tonal gradation is then executed with a series of grays in which the brightest high-lights are added at the end with white chalk.

Sketching and shading with red chalk on colored paper.

Increasing the presence of brown in the darkest areas.

Degas: Light and the Figure

Most of Degas' works were executed in pastel. The artist favored this medium because of the spontaneity of the images produced.

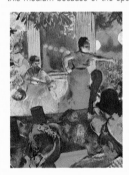

His pastel masterpieces depict figures of an almost photo-graphic nature, seen in strong light. In addition to the natural aspect of its figures, Degas' work is also characterized by its use of light, an effect rendered through the use of pure colors with barely any blending.

Edgar Degas, Le Café-concert des Ambassadeurs.

Application of white chalk in the brightest areas.

Tonal gradation achieved by blending with the fingers.

Details and the Planes of the Forms

The details of the figure should be added at the end, since the inclusion of these fea-tures too early in the process may prevent a correct position-ing of the figure's different planes. The brightest parts of the work should be left until the very end in order to prevent them from getting contaminat-ed by other colors.

The Stroke in Drawing and Painting

Both pastel and chalk can be used to produce various types of strokes. If you examine a pastel stick, you will see that it is square shaped. This allows you to make three different types of line. Using the end of the stick you can draw the basic forms of the figure and add highlights and very fine details. The corner or side of the stick allows the artist to sketch the initial lines of the model; lastly, to fill in broad masses, the stick is placed face down on the paper and moved from side to side. These three types of strokes, together with blending with a stump or the fingers, form the fundamental techniques of chalk and pastel.

| **MORE INFORMATION** |

• Techniques: sketches in charcoal, **p. 60**
• The figure in motion, **p. 64**

THE STUDY OF ONE OF DEGAS' FIGURES IN WAX CRAYON

Despite their popularity and the fact that many artists have mastered the technique, wax crayons are one of the most unusual pictorial media. Encaustic was widely used in ancient times. Nowadays, due to the complexity of its preparation, this medium has disappeared and been replaced by others that are easier to handle. Nevertheless, its plastic results remain equal or even superior to those of more modern media. There is no better way to familiarize oneself with this technique than studying one of Degas' masterpieces.

The Preparatory Drawing and the First Layer of Color

The preparatory drawing for a figure study with wax crayon can be executed with any dry medium. However, charcoal is considered the best, because it can be immediately corrected and does not remain visible under opaque layers of color. The figure should be blocked in rapidly, sketching only the general forms, without attempting any gradation or adding any detail.

Applying the first tones of wax crayon: gray contrasted with warm tones.

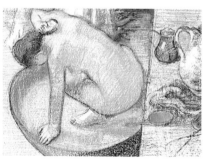

Color and the Stroke

Over the first layer, we can begin adding colors that allow us to glimpse the primary coat. The new addition alternates cool tones (violet) with warm ones (ochers and earth tones). Applying strokes lightly, so as to prevent the grain of the paper from being filled in, the general forms are drawn in greater detail and the shadows cast on the ground by the figure are indicated.

The type of stroke used for each area defines the plane occupied by the form. In this manner, the figure's volumes

Warm tones are applied with soft strokes over the gray base color.

The figure's different planes are expressed by an increase of color in the areas of shadow, while the brighter parts are represented by the color of the paper itself.

are modeled by leaving lighter areas at the points of most light and by increasing the color to mark the presence of shadows.

Chromatic Balance

Tones are successively added by alternating a dense, closed stroke with a freer, almost drawing-like stroke.

The colors are intensified in the dark areas and, despite the superimposition of planes, the forms are modeled according to the direction of the stroke.

A hog's hair brush dipped in turpentine is then used to blend and mix some of the areas of denser shadow; such color blends will later provide a base on which more defined strokes can be added.

A brush dipped in turpentine is used to blend the denser shadows.

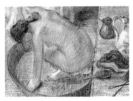

New strokes are added over the blended base color, modeling the forms according to the direction of the strokes.

MORE INFORMATION

• The figure and color ranges, **p. 24**
• Flesh tones in figures, **p. 44**

Hues and Details

Once the base color has been applied, the artist begins to accentuate the density of the strokes, filling in the grain of the paper by increasing the pressure on the crayon, modeling the form of the stroke and blending it by pressure with the underlying colors.

The lightest parts are represented with tones of gray and white, while the shadows are suggested by grays alternating with blue and warm tones.

Finally, in order to unify the entire composition, a grayish stroke is used to merge the masses of color into one.

Highlights and hues are indicated with tones of gray and pure white.

The figure is completed with a grayish tone that unifies the whole.

Drawing in Negative

The technical application of wax in the representation of the figure is not subject to plastic limitations. The technique of drawing in negative is very simple. Once you have made a drawing indicating the most basic lines of the model, without any gradation, you can cover all the areas intended to remain white with white wax, paraffin, or even the end of a candlestick. If the paper is grainy and you want to create areas of pure white, you must continue to apply wax until the grain has been filled in. You can also choose to leave the grain partially covered, with a lighter application of wax. Once this process is completed, you can go over the drawing with wash without its affecting any of the areas where the wax was applied.

The technique of negative drawing.

After drawing the figure with its shadows, the parts of the figure to be left in reserve are covered with white wax. Once this has been done, a diluted wash is applied over it; it will affect only those parts that have not been reserved in wax.

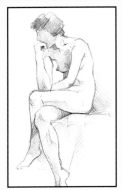

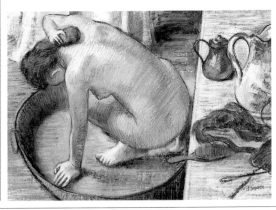

TONAL GRADATION AND THE USE OF COLOR IN THE FIGURE

Ever since Impressionism, painting has been understood in two basic ways, independent of the pictorial style adopted. First, volume can be suggested through shadows—that is, the figure's tonal colors are gradated towards the darker tones. Second, shadows have their own specific colors that do not correspond to a tonal gradation.

Ingres, Self Portrait. *A perfect gradation of different tones.*

Tonal Light and Local Light in the Figure

Gradation is a process by which a two-dimensional representation of a figure is rendered through the use of various gray tones. The model is represented chromatically by understanding the tones of shadows as darker values of the model's light color.

Cézanne, Self Portrait. *A perfect understanding of the use of color.*

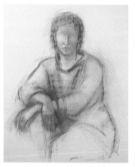

The shapes have been developed from a first gradation of tones, gradually separating lights and shadows.

Gradating the Figure with Color

The figure can be interpreted as a series of tones that darken as the volume recedes further away from the direction of the light. The tonal gradation of a figure begins by applying the two opposite tones—that is, the lightest and darkest colors—corresponding to the areas in shadow; then intermediate tones are added and merged (or blended, if you are working in pastel) with the previous ones.

MORE INFORMATION

• Two styles of painting, **p. 34**
• Modeling the figure: watercolor and drawing, **p. 42**

Color Gradations and Grays in Forms

The gradated vision of the figure is based on a color gradation that is treated in the same way as a gradation in gray. For this reason, it is useful to draw several sketches and studies of the figure using

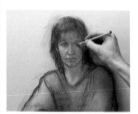

The gradation was executed monochromatically, alternating only two pastel tones.

monochrome media, such as wash or, among drawing media, pencil or charcoal. Studying the gradation of grays leads to greater understanding of gradation in color.

The process of gradation is essential for suggesting the modeling of the figure's forms.

Opening up delicate whites with an eraser pencil.

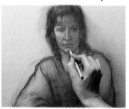

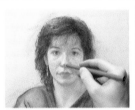

The gradation is completed by softening the contours with a lighter tone. Lastly, using a stick of white pastel, several highlights are added to complete the modeling.

Coloration and the First Impression

The colorist painter interprets the model from a completely different perspective. The darkest tones are perceived as pure colors, and not as gradations of the initial color. Consequently the colors themselves create the volume of the figure. These colors do not necessarily have to belong to the range of the brightest color of the object. The relationship between them is not created by gradation or value but by both chromatic and tonal contrasts. An arm, for instance, may be painted with Naples yellow and a touch of carmine in its brightest part,

while the shadows can be filled with planes of yellow-orange cadmium darkened with burnt umber.

Sketching the preliminary drawing of a tonal picture.

The colors have been applied directly by planes and without gradations.

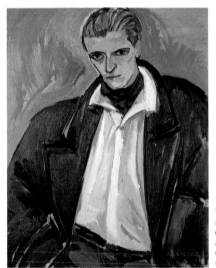

The dark tones are colors independent of the bright tones.

Where Is the Real Color?

The color of the figure, like the rest of the picture, is left up to the artist's interpretive vision. The real color of the figure is established by the light and the colors of the surrounding objects; this is why the colors of a figure will change when placed in a different context. Once you have adopted a coloristic or a tonal interpretation of your subject, you can develop your work as you see fit.

From Coloration to Pop Art

The advances of the Impressionists in the field of color were pushed further by Postimpressionists, such as van Gogh and Gauguin, developing into Fauvism. Fauvism, in turn, had a deep influence on Pop Art, an artistic movement that began in New York in the late 1950s by artists such as Andy Warhol. The high use of color became the main form of interpretation of this artistic trend, in which figures were represented in flat planes of pure color with no gradation. Today, Pop Art continues to have an influence on new artistic works.

Tomas Lobo, Resting in Acid (1996). Computer-enhanced electrographic process.

TECHNIQUE AND PRACTICE

THE CLOTHED FIGURE

The clothed figure presents many problems that must be solved differently from those encountered in a nude. The structure of the figure drawing should not differ, but different hues can be introduced to suggest the texture of the clothes or the additional lights and shadows cast over the figure by the folds of the fabric. The study of the clothed figure is important for understanding the model in its surroundings.

Sketching the Figure

The internal construction of the clothed figure should be the same as for a nude. This is easily explained: If you start from an outline of a figure in which the proportions are correctly defined, you can then build the volume and shape of the clothes on top of this perfect construction.

The use of a geometric plan to block in the general forms of the nude is equally valid for the clothed figure, bearing in mind that instead of fitting the model as snugly as a glove, clothes

The result of this sketch in red chalk is a completely structured figure.

Features are added to the face and the body is given more volume.

produce volumes that can distort the shape of the figure if it has not been blocked in correctly beforehand.

Clothes and Their Volumes

Once you have drawn the initial structure of the figure, you can begin to add the clothes, taking into account the effects produced by the position of the limbs; beginners frequently make the mistake of placing creases where there are no joints.

The volume of the clothes must be represented in a

The body is drawn over, building up the volumes of the dress.

logical manner, in order to suggest the way the fabric falls over the body. Failure to do this will result in a cardboard figure. While clothes cling to some parts of the body, the weight of the material can make them stand out in others.

In this study of light and shadow, the fall of the material is defined by the direction of the shadow.

Blending the strongest shadows with a cloth.

MORE INFORMATION

• The clothed figure and its anatomy, **p. 52**
• The clothed figure in oil, **p. 88**

The gradation is executed in such a way as to exclude unnecessary details.

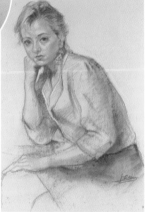

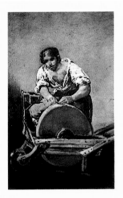

A Masterly Example

The work of Goya (1746–1828) is a magnificent lesson on how to interpret the synthesis of a clothed figure in painting. With a few sure brushstrokes, he was able to create just the right amount of volume and highlights to suggest in an abstract manner numerous details that are actually not in the painting.

Francisco de Goya, The Knifegrinder.

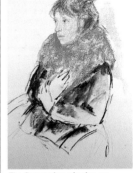

The first strokes of color are applied to the face and the darkest parts the clothes.

The Movement of the Clothed Figure

The representation of a static clothed figure is relatively easy, since its volumes can be studied at length. However, when drawing a figure in movement, we must study not only its internal structure but also the volume of the clothes. The planes of the fabric do not necessarily follow the law of gravity; creases and lines are produced in different places depending on the weight and texture of the fabric and the extent of the movement.

Color and Dispersion as a Technique

In some figurative scenes, it is not necessary to paint in great detail the forms of a clothed figure. Sometimes a few touches of color are enough to represent a suit or a dress. The color of the paint itself can express the shape of the clothes that define the body of the figure. When you are drawing a picture in which the main subject is not the figure itself, its presence should not be overpowering and discreet tones and colors should be used.

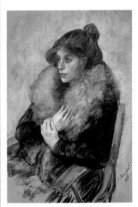

The most detailed work takes place in the face and the fur around the neck, while the fabric of the sleeves is made darker in the area of the folds.

Synthesis of Forms

In order to paint a clothed figure correctly, the artist must synthesize the most important lines of the subject from the outset. By eliminating all unnecessary details, the remaining forms will stand out better. The forms of the figure, either static or in motion, must determine the volume of the clothes, clearly indicating the planes of light and shadow, as well as the planes of the figure that are closest to the viewer.

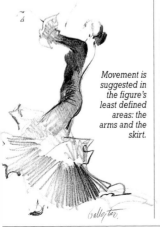

Movement is suggested in the figure's least defined areas: the arms and the skirt.

The sketch includes the figure's general outlines.

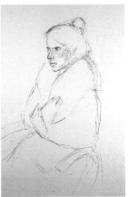

TECHNIQUE AND PRACTICE

THE CLOTHED FIGURE IN OIL

In the representation of figures, special attention must be given to clothes, as artists specializing in nudes may encounter difficulties when trying to depict various types of clothes. The study of folds and creases is closely related to the anatomical study of the model; that is, the shape of the figure determines everything that envelops it.

Light Over Volume

One of the most important aspects of a study of clothes is the effect of the light falling on them. The volume of the forms created by the clothes must be studied along with the way they are lit. Depending on the direction of the light, a tiny crease may stand out or, on the contrary, appear almost flat.

When light strikes the fabric from the side, the slightest change in volume will appear as a sharp contrast. If, on the other hand, you place a reflector (a simple white screen) opposite the light, the contrast can be softened.

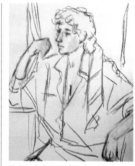

In this drawing of a clothed figure, the artist has taken into account the fact that the volume of the clothes is supported by the structure of the body.
The drawing was executed with the flat side of a charcoal stick, except for the face and hair, where more details were added.

The Representation of Clothes in the Preliminary Drawing

In sketches intended both for drawing or painting, the artist must pay special attention to the folds and creases in the clothes covering his model. He must note where they begin, where they divide, and when they flatten out.

Because the twisting of clothes follows the shape of the body, the lines of the folds can be included in the initial sketch, in accordance with the anatomy of the figure. The process of gradation begins as the forms are reinforced, first in drawing and then, once the entire sketch is completed, by

This is the palette chosen to paint this picture.

the application of colors. The chromaticism of the painting is then refined, observing the soft gradations and the abrupt transitions between light and shadow.

Some areas of the drawing are filled with an earth tone, which is also used to indicate the main lines.

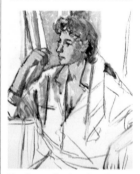

The first application of small energetic strokes will serve as a chromatic guide for the picture as a whole.

Once the face and part of the background have been painted, the artist turns his attention to the figure's clothes.

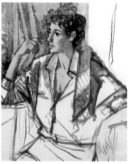

MORE INFORMATION
• The clothed figure and its anatomy, p. 52
• The clothed figure, p. 86

Touches of color are applied in one direction, with small brushstrokes that form planes.

The Study Made with Drawing Implements

Charcoal, graphite, or lead pencil can be used to execute an in-depth study of the tonal gradation and structure of the most important folds and creases. Synthesis is as important in the study of creases as it is in all other aspects of the picture.

Only repeated studies and sketches can give us the mastery of the volume and forms of folds necessary to draw them naturally.

Light and Shadows

The treatment of the light falling on the fabric is very important, both in the gradation and application of colors. The shadows cast on the clothes must belong to the color range being used. A darker tone of the same range can be added to the base color so that it blends with the lighter colors without creating a sudden break. In the same way the base color of the clothes should be of the same general tone as the color range being used.

From Model to Art Work

When we observe a model, we must see it in synthesis in order to transfer only its most important lines to the canvas. With an in-depth study of the areas of light and shadow, we can begin to understand the folds and creases of the model as masses of shadow. Each type of fabric, such as a sheet or a blanket, has its own particular texture. Therefore, the artist must draw studies of all kinds of materials and compare the differences.

Somewhat darker brushstrokes are applied in the areas of the folds.

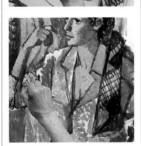

When drawing folds and creases, it is essential to remember that their direction is determined by their point of maximum tension.

The hardest shadows are softened with tones approaching the points of maximum brightness.

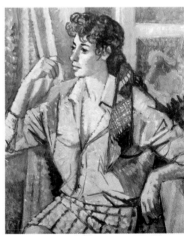

Avoid retouching the figure too much in order to keep its spontaneity.

TECHNIQUE AND PRACTICE

PRACTICING COMPOSITION WITH FIGURES

Composition is the art of distributing different elements of the model throughout the
painting with a view to creating a harmonious and well-balanced ensemble.
By including several different figures in the work, or even repeating the same model in
various poses, the artist can produce interesting compositions, playing with
the arrangement of the different weights, the colors, or just the volumes of the forms.
The best way to understand the art of composition is through practice.

Compositions with Figures

The human figure provides numerous compositional possibilities in painting, either as a single referent or as part of a group.

Artistically speaking, the human figure is one of the most malleable elements at the painter's disposal. Its composition can be adapted to practically any geometric format. Therefore, independent of the selected model, the artist should know from the beginning what form his composition will take. It is also always advisable to develop the composition and the study of the model simultaneously.

References

In all figurative compositions, the background has an

Jacopo de Barbari, Portrait of Friar Luca. *Trapezoid composition.*

effect on the main subject. Therefore, the greater the importance of the figure, the fewer compositional lines the background should have.

The subject of the painting is always blocked in within a basic geometric shape that best represents the rhythm and distribution of the masses in the picture. A figure might fit

This group of figures can be blocked in within a circle.

within a square or circle, for instance; the lines that structure the background should reinforce this composition.

MORE INFORMATION

• The figure as the main theme, **p. 30**
• Different ways of framing the figure, **p. 38**
• Composition and the golden rule, **p. 46**

Francisco de Goya, Help. *Circular composition.*

Matisse, the Genius of Composition

The figures in Matisse's (1869–1954) work serve two purposes. On the one hand, the simplicity of the forms and color lend an almost musical rhythm to the work. On the other hand, this cadence of forms and color emphasizes the compositional qualities of the figures themselves. The figures are perfectly translated into geometric shapes, both in the preliminary drawing and in the coloring process.

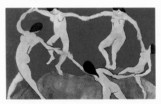

Henri Matisse,
La Danse.

Balance and Composition

A group of people seated can provide an interesting subject for a painting. In the preliminary sketch, the first thing to do is to find the compositional balance. This is achieved by focusing on the forms or colors, indicating with sharp contrasts areas that are not related to one another. Once a general balance has been created between the forms, the artist can establish a relationship between the different shapes of the figures and the elements making up the background.

In order to establish a color range that will develop as the painting progresses, the artist starts to paint the tones of the figures within a specific range.

The painter adopts an overall chromaticism dominated by a range of warm colors, always remembering that in watercolor, the lightest tones must be applied first.

The background is painted with two tones: blue and a grayish blue.

Adjusting the background helps greatly in finding the balance and composition of the figures.

Color and Composition

In the same way as the different elements of the picture relate to each other, a relationship has to be found between the forms of the figures and the edges of the picture. Color is also very important in establishing the balance of the composition.

In a monochrome picture, the balance of tones is achieved through gradations of grays according to the logic of the laws of gravity—that is, since darker tones weigh more than light ones, the darker tones should be put in in order

to produce a harmonious composition. When color is used in the composition, tones not only influence the balance of the composition, but color comes to play a major role. Balance is achieved when colors are placed correctly in terms of their temperature; thus warm colors appear to be closer and cool colors further away.

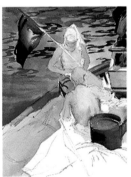

Warm colors in the figures contrast with the coolness of the background.

Once the background has dried, a warm glaze is applied to give unity to the ensemble and chromatic coherence to the flesh tones.

Geometric Formulas

There is no single rule for successfully composing a figure from a geometric shape, but it is true that seeing the main lines of the picture as a circle, polygon, and so forth, greatly helps to establish a balance between the forms of the composition.

The balance is almost perfect, both in terms of form as well as chromatic distribution.

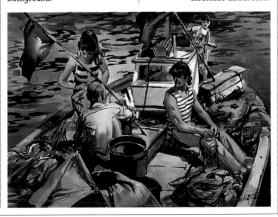

TECHNIQUE AND PRACTICE

PAINTING AND SYNTHESIS

Synthesis is the art of reducing an object to its most essential forms while retaining its specific identity. It is possible to synthesize any existing shape in nature. This process requires a great effort on the part of the painter to eliminate all the unnecessary elements from a figure in order to represent it in essence.

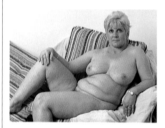

The model should be synthesized, capturing the body's volumes and masses by means of lines and lighter washes in the highlighted areas, and darker ones in the areas in shadow.

The Figure Plane

Painting a figure involves transferring a three-dimensional model to the two-dimensional plane of the canvas. In other words, the model's plane in the painting should be defined in synthesis, reducing existing forms and colors to their simplest plastic expression, through modeling and color gradation. In a painting, volume is interpreted as a series of tonal and chromatic variations developing over different planes. A specific volume

The lines define the figure.

is therefore understood as a series of planes producing a visual effect of modeling.

Simple Forms

The planes of a figure must be defined on the canvas before the work begins. Understanding the figure implies that you are able to identify the main lines and planes that make up its different volumes or features. Those planes are based on the synthesis of the figure's main forms and express all secondary volumes in very simple shapes. Once this step is complete, we can begin to complete the figure with tonal gradation or the addition of color.

Without including any details, the simple forms are indicated by flat applications of paint over the masses of each of the body's areas.

The Strokes

As we have seen, the figure is constructed on the basis of

The preliminary washes, comprising diluted layers of paint, cover the broadest zones.

several preliminary sketches that allow us to make a correct assessment of the figure's different aspects. Depending on the pictorial medium, the figure will be completed more or less rapidly through successive layers of paint blending with the earlier layer to model the forms.

With opaque media, such as acrylic, oil, tempera, or pastel, the coloring process starts with

Bringing out the volume. The synthesis of forms in this sketch is fundamental.

Through the blocking in it is possible to see which planes form the different masses.

The large color masses in the background demarcate the figure and heighten its volume.

a series of general tones that will be further enhanced by the addition of subsequent lighter or darker touches. With these media, the subject's forms can be modeled by superimposing light planes of color over dark ones.

The study of the different planes of color varies according to the area; in this case, the leg is painted with a grayish tone that allows the underlying color to remain visible.

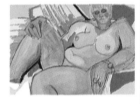

Direction and Plane Depending on the Medium

The forms of the figure are constructed through planes that model the volume according to the direction of the light.

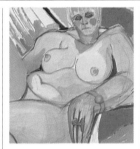

The volume of the forms is suggested by the light falling on them, and should therefore be expressed in light tones.

The areas of light and shadow suggest the model's volumes. These areas are always defined by modeling the plane according to the direction of the light. In media such as oil, acrylic, or tempera, the different planes suggest the volume of the model according to the direction of the model's plane, with brushstrokes as an extension of the form and not of the drawing. With the direct medium of pastel, by contrast, volume is constructed by following the direction of the plane that is being represented. This search for volume through planes is also carried out through synthesis, always summing up as much as possible the different additions of color.

In this work by Esther Olivé de Puig, the synthesis of forms and color has been studied with the utmost care, so that only the elements that best express the forms are included in the painting.

Velázquez: Complexity Made Simple

Velázquez (1599–1660) was an expert at synthesizing forms and color. His mastery of drawing is well illustrated in his work, which was almost always painted directly on the canvas. For this reason, we know only a few drawings by the great master. Velázquez' dexterity with the brush allowed him to synthesize the most complex forms with extraordinary speed. His secret was to make a separate study of the space occupied by each of the figure's forms and to develop the planes according to a correct assessment of the light.

Velázquez, Las Meninas.

Proportion and Synthesis

The search for synthesis in a painting is completely unconnected with the proportion of the forms that are being represented. Assuming that the painter starts from a good sketch in which the different proportions of the figure have been thoroughly studied and drawn, the placement of the figure's different planes should not be difficult.

MORE INFORMATION
• The parts of the body and their outline, **p. 16**
• The figure as the main theme, **p. 30**
• Figure and abstraction, **p. 48**

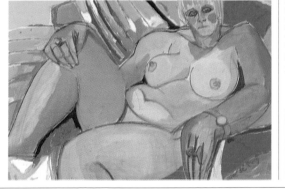

FIGURE AND PORTRAIT

The theme of the figure can be applied to any pictorial genre, adapting itself to each one in particular. In the portrait, for instance, where the figure plays the most prominent role, from the pose on, the person being painted acquires personality in the work, which does not just consist of painting the face and features correctly.
The choice of the person being portrayed is rarely random. It is important to know something about your model before undertaking the work, as well as knowing how to draw, in order to make a good portrait.

In the initial sketch, the artist concentrates on the most important elements.

The forms should be developed according to the importance given to the figure.

The Preparatory Drawing and Composition

In a portrait, composition is one of the most essential elements used to express the importance and nature of your model. Therefore, the relationship between the background and the figure must be established correctly in the initial sketch.
The drawing should always include all the references necessary to paint the figure, with the most important areas worked in slightly greater detail.

The Planes of the Figure in the Portrait

Likeness is not the only quality of a good portrait; with practice, physical resemblance can be achieved with relative ease. Personality, by contrast, is much more difficult to represent.
The pose taken by the model is as important as the correct representation of the features. The structure of the figure's basic lines relinquishes many of the general features, which can be summarized as geometric forms defining the most interesting planes of the portrait.

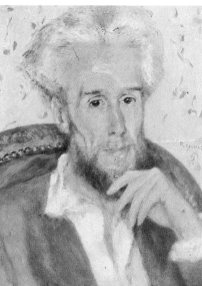

Renoir, Portrait of Victor Chocquet. In this bust portrait, the study of the structure of the head helps the painter understand the different planes of the body, as well as the position of the main lines.

Pose and Character

In a portrait, the figure's pose is a reflection of the model's personality. For this reason, the pose should never be treated as a simple study; the cadence of the forms, the gesture of the arms, or the simple position of the head are essential points to bear in mind when expressing personality.

The pose of a model can be captured within a basic sketch. Note in these masterpieces how the pose affects the way in which we see the person portrayed.

In Self-Portrait with a Hat, *Manet stands in defiance before the viewer. The basic triangular sketch of his pose indicates a great strength.*

In his Self-Portrait in a Dinner Jacket, *Beckmann seems to be looking at himself in a mirror in a contemplative pose dominated by a rectangular structure.*

MORE INFORMATION
• The figure as the main theme, **p. 30**
• Practicing composition with figures, **p. 90**

The Appropriate Technique

Each artist develops his own method of painting. If you were to ask, for instance, three different artists to paint the same portrait in the same medium, the results would vary considerably. Once he has learned how to paint, each artist must develop his own pictorial language.

The Figure and Personality

The portrait should be entirely determined by the model's personality. The artist must remember this fact in order to produce a successful portrait. As we mentioned earlier, the series of lines and forms provided by the model allows the artist to capture the gesture of the pose. In the initial study, the most important forms are governed by the position of the head and its relationship to the rest of the body's lines; in this manner, the portrayed figure departs from the preestablished standards and is represented in a different way each time.

Modigliani, Lunia Czechowska. *This portrait can be reduced to a double oval. The figure's slightly tilted head and curved forms reflect a delicate personality.*

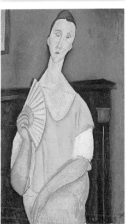

Original title of the book in Spanish: *Figura*.
© Copyright Parramón Ediciones, S.A. 1996—World Rights.
Published by Parramón Ediciones, S.A., Barcelona, Spain.
Author: Parramón's Editorial Team
Illustrators: Parramón's Editorial Team

Copyright of the English edition © 1997 by Barron's
Educational Series, Inc.

All rights reserved. No part of this book may be
reproduced in any form by photostat, microfilm,
xerography, or any other means, or incorporated into any
information retrieval system, electronic or mechanical,
without the written permission of the copyright owner.

All inquiries should be addressed to:
Barron's Educational Series, Inc.
250 Wireless Boulevard
Hauppauge, New York 11788

International Standard Book No. 0-7641-5008-1

Library of Congress Catalog Card No. 96-86677

Printed in Spain
9 8 7 6 5 4 3 2

Note: The titles that appear at the top of the
odd-numbered pages correspond to:

The previous chapter
The current chapter
The following chapter